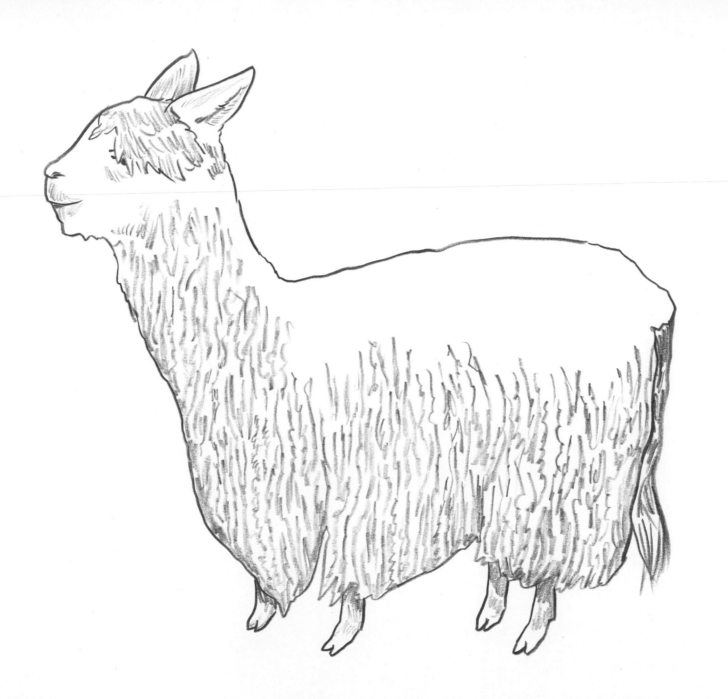

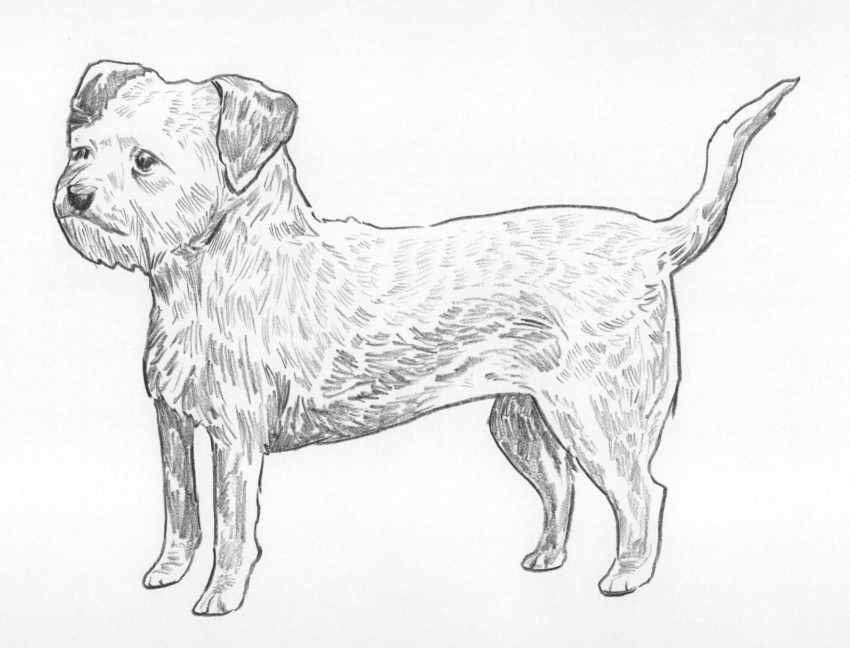

UNGRATEFUL

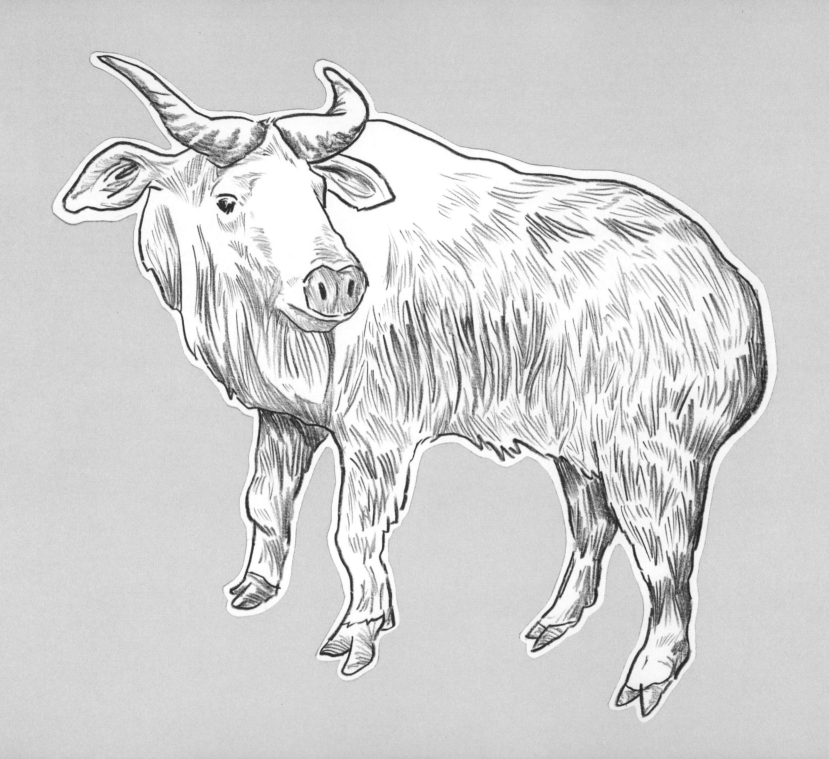

MAMMALS

DAVE EGGERS

ABRAMS, NEW YORK

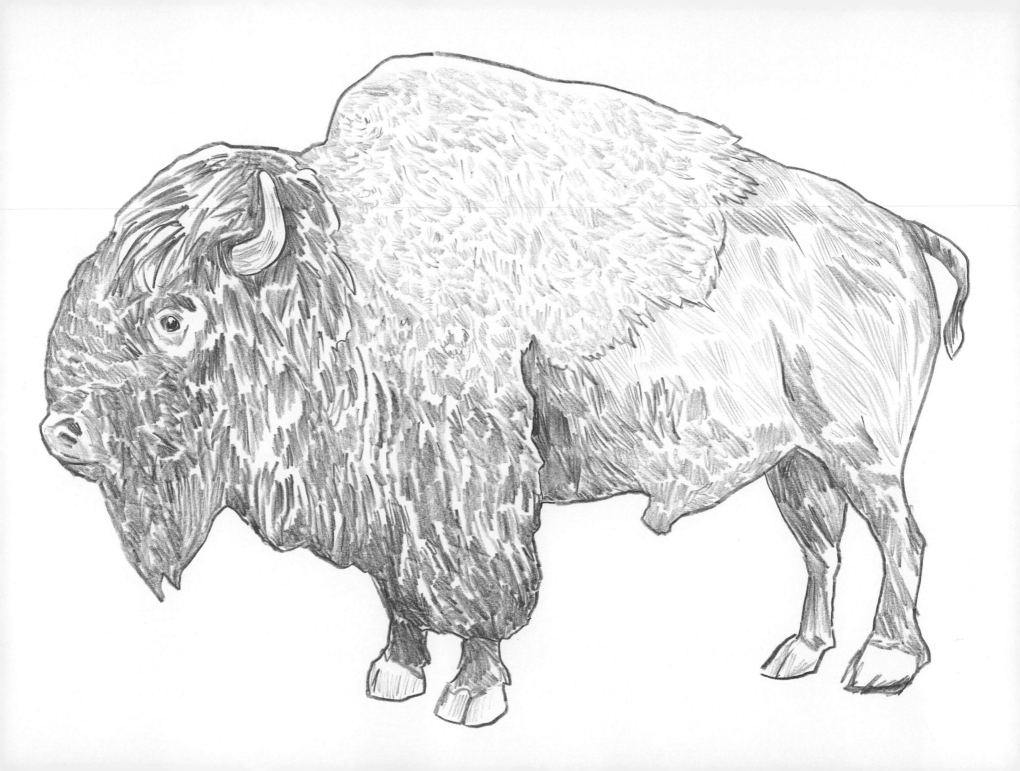

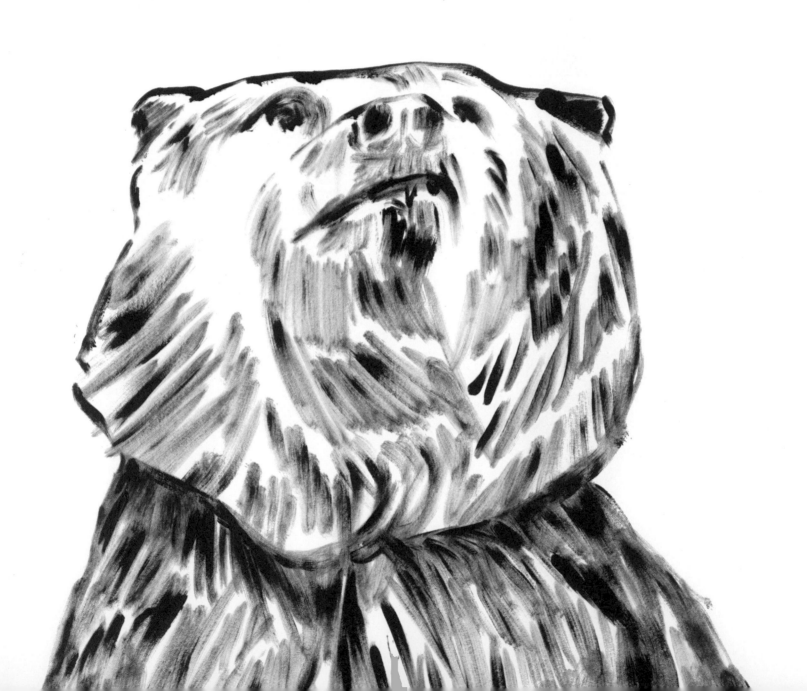

MY SENSE OF THE NEAR-NESS OF DEATH

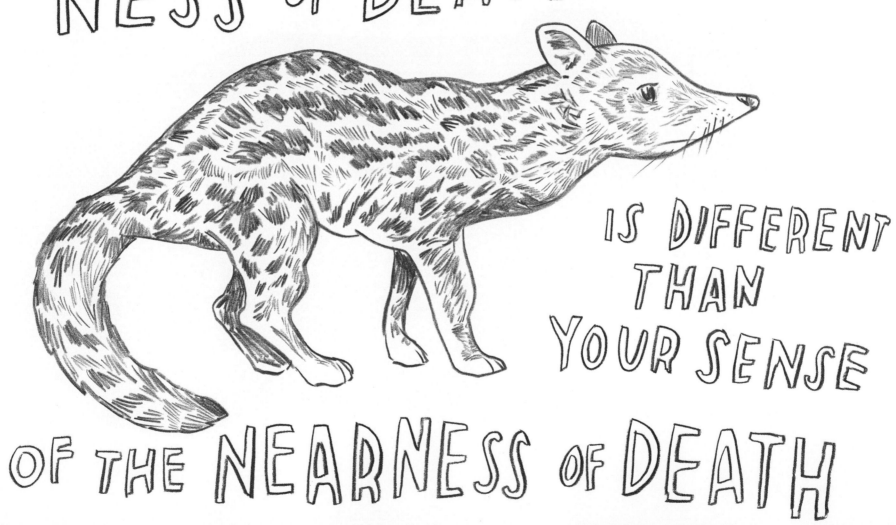

IS DIFFERENT THAN YOUR SENSE

OF THE NEARNESS OF DEATH

So what are these artworks? I'll explain as much as I know.

I was trained in the classical way of drawing—to be able to capture a likeness or shape in a realistic way. I wanted to draw and paint like Manet and Caillebotte, so for years I rendered people and things in a representational way, usually in some slightly surreal or (I hoped) thought-provoking setting or situation. Then I stopped painting in earnest for the better part of fifteen years.

Recently, I've come back to drawing and painting, with animals as the subject. I honestly can't remember exactly when it started, but I began drawing bison from photos I'd taken in Alaska and Idaho, and once I'd finished a given drawing, it seemed incomplete without text—and the text that seemed most appropriate usually involved the bison in dialogue with its creator.

These bison-and-text paintings evolved to include an array of mammals, and an array of dialogues. Sometimes the animals question their existence or purpose. Sometimes a passage from the Old Testament surrounds them and in some way gives them a sense of mission. But usually there exists tension between the animal and an unseen God, and in all cases I try to bring out the soul of the animal.

I can't disguise the fact that I enjoy making these pictures. More so than when I was a student, the process is loose and uncomplicated. You may guess that some works seemed to have been created in a fever, and you would be right. Recently, a large group of animals was the product of one long painting-bender, one of the most joyful few hours of artmaking I've ever experienced.

I hope you enjoy looking at these pictures.They were made with great affection for their subjects and for their potential viewers. It means the world to me that you're looking at them.

INTRODUCTION
NOAH LANG

I remember the first time I walked into the Pirate Store. It was 2002 or 2003. I had heard there was a store that was selling peg legs, eye patches, and planks (for walking) in the Mission District of San Francisco. At that time I hadn't connected the dots in the constellation of McSweeney's, Dave Eggers, 826 Valencia (the writing center), and 826 Valencia (the Pirate Store). I was, however, at first blush, charmed (by pirate wares and the byzantine merchandising scheme), and also charged up (by their generous, invigorating, and fun attitude toward honing children's literary arts skills—for free).

I felt the pull to jump into that scene, but I was running a fine art publishing business and gallery with my father in a bone-crushingly fervent style and couldn't do both things well. What we could do well was support 826's literary deeds with our visual ones. We published prints in support of 826 over the years with many local and national artists, and an informal, collegial bond was formed between us.

The story picks up again when Dave came to an opening at the gallery, Electric Works. He casually mentioned to me that he had some drawings and asked if I would like to see them. The first reflex was, "Oh God, how do I let him down easy?" The pessimism didn't have anything to do with Dave or any of my experiences with him; the running of an art gallery has some hazards—one of which is "an-accomplished-someone-in-one-field-decides-that-they-can-do-artwork-as-well-and-thought-you-might-really-really-really-enjoy-seeing-their-paintings." I had been down this road before and it had always been nothing but barren and dusty. I asked myself which sort of situation I had on my hands: A Shatner or a Nimoy?

We had fostered a supportive atmosphere between our institutions, and, I have to admit, I was curious. Many of the drawings I saw in that first batch, delivered to us the very next day, are in this book. I was simply taken with them. There was much to admire. A surety of line, a serene sense of pathos (and ethos, while we're at it), humor, and simplicity that all function so effortlessly together that it makes viewing them (and imagining making them) such a pleasure. I later learned that he had studied studio art in college and had looked forward to returning to the work after taking an extended break from it. So, wait, perhaps the whole time, writing was the side project. Lucky for us, he returned to his vocation.

We decided to do a solo show at our gallery. McSweeney's produced an inventive loose-leaf portfolio, which served as a hang-it-yourself exhibition in a box. Dave immediately went to work on installing the shows, including painting directly on the gallery walls. He had keys and worked feverishly through the nights. During the installation, we would arrive every morning at the gallery to see what new work was on our walls. We have been working together ever since. All of the projects we have undertaken over the last ten years have generated a feeling you don't get with every artist. It's been one of trust, ease, generosity, and serious fun. And what, I ask, is better than that?

Noah Lang, along with his wife, Kris, owns Electric Works, a multifaceted art-making studio, which he founded with his father in 1995. He has worked on projects and collaborations with myriad artists including David Byrne, Enrique Chagoya, R. Crumb, Marcel Dzama, Alicia McCarthy, Trevor Paglen, Clare Rojas, David Salle, Wayne Thiebaud, Larry Sultan, Lawrence Weiner, and William T. Wiley, resulting in books, records, fine art multiples, limited edition prints—even pinball machines. He has a Masters Degree in Science and lives with his wife and two children in San Francisco.

INTERVIEW WITH DAVID TILLEY, WHO SPENT COUNTLESS HOURS WITH THESE DRAWINGS AND SURVIVED

1. What is your position at the Nevada Museum of Art?
I'm a Visitor Services Officer, which means I protect the artwork but I'm also focused on making sure that patrons get as much out of the museum as possible.

2. How long have you held that position?
I've worked at the museum for just over three years.

3. Were you an art appreciator before working at the museum?
Absolutely! I started working at the museum while pursuing a BFA up at the University of Nevada, Reno. I've always loved spending time in art museums, and getting paid to do it while working on my degree seemed like a perfect opportunity. I feel like being exposed to hundreds of new artists and artworks over the last few years really strengthened my own work and helped me immensely with school.

4. What kind of art do you gravitate to when you're not working at the museum?
I really enjoy sculpture, especially large, room-sized installations like the ones that Henrique Oliveira and Maya Lin do. I've also become hugely appreciative of letterpress and other text-based artworks after getting to work within that medium at the university.

5. When these animal drawings went up at the museum, what was your first impression?
At first I was struck by just how many of them there were. We've had a few shows hung salon-style, but nothing approaching that level of density. I was also drawn to how sympathetic the animals were. They were all rendered in a really simple, iconic way that drew me to their eyes and melancholy expressions. That, in combination with the text, made them kind of irresistible. I spent a lot of time in that gallery when the show first opened. I always felt like I was finding something new.

6. What kind of person did you think would create such work?
The text seemed so all over the place, drawn out of everything from religious texts to late-night diary entries. Some of it was absolutely hilarious, and some of it was kind of devastating. I still think about one that said, "Let's love each other as if we loved each other" fairly often. It seemed like a relatively unfiltered look into the artist's interests and obsessions. Somebody who's looking into deep questions but still has a sense of humor about it.

7. What reactions did you see from the public?
People spent more time in that gallery than they usually would, reading all of the text, picking out favorites. Little kids were especially drawn to them, not so much for the text (though the smaller ones were always excited about figuring out what they said) but because of the huge variety of animal subjects. Many school tours left with kids debating whether the bears, the apes, or the bison were the best.

8. Do you believe animals have conversations with God?
I'm not really somebody who believes in God, but it would make sense for animals to. An Old Testament God, fickle and prone to wrath, might explain the suffering of daily life in the wild. I feel like that's why we're drawn to that too. It makes it easier to have somebody to blame when everything is crashing down around you.

9. Do you think these animals have a right to complain, or should they be happy for what they have?
That's what always troubles me about animals. They don't know enough to complain, only to suffer. They go through life seeking only survival and the propagation of their species, and I'd hope that they'd find some contentment in that at least, but it's kind of impossible to tell. Death is so sudden, and hardships are so hard to avoid.

10. Which animals, if any, might be most right in their grievances?
Livestock maybe, though I never know if they can understand what's in store for them. I know they understand pain, at least when the end comes. I do feel for the smarter animals, especially chimpanzees, dolphins, and elephants. They might not be penned in for slaughter, but they have a better understanding of what's happening around them. I have to wonder if they understand even a portion of the cosmic cruelty of their circumstances. If they do, even a tiny bit, then I'd say that they should definitely have the right to complain, and a lot to complain about.

UNGRATEFUL MAMMALS

LET'S GET THIS PARTY STARTED

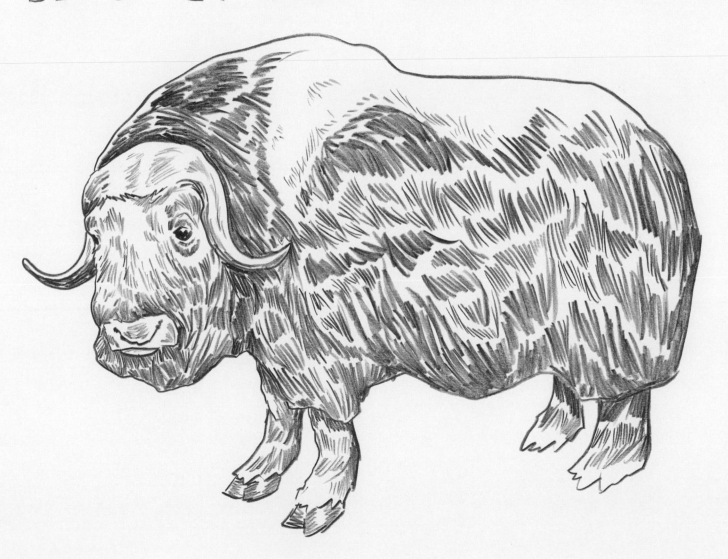

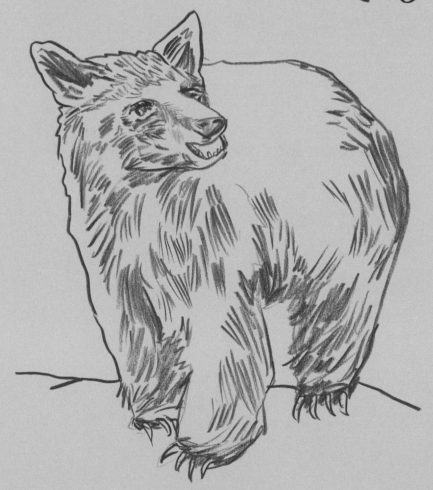

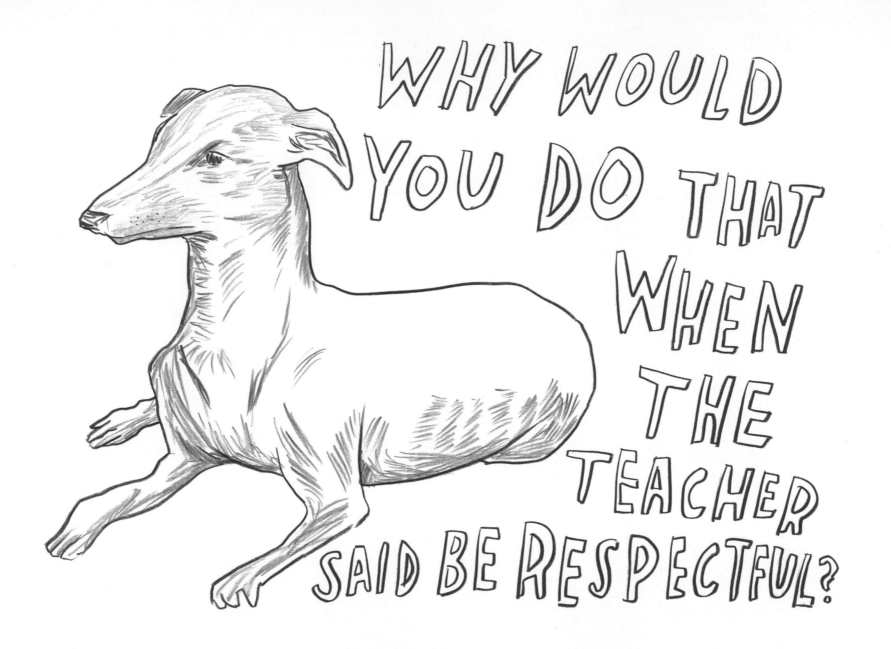

GIRLFRIENDS RULE

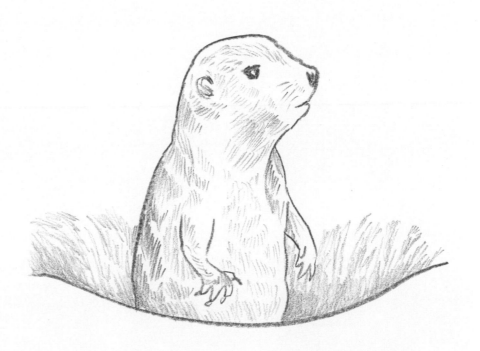

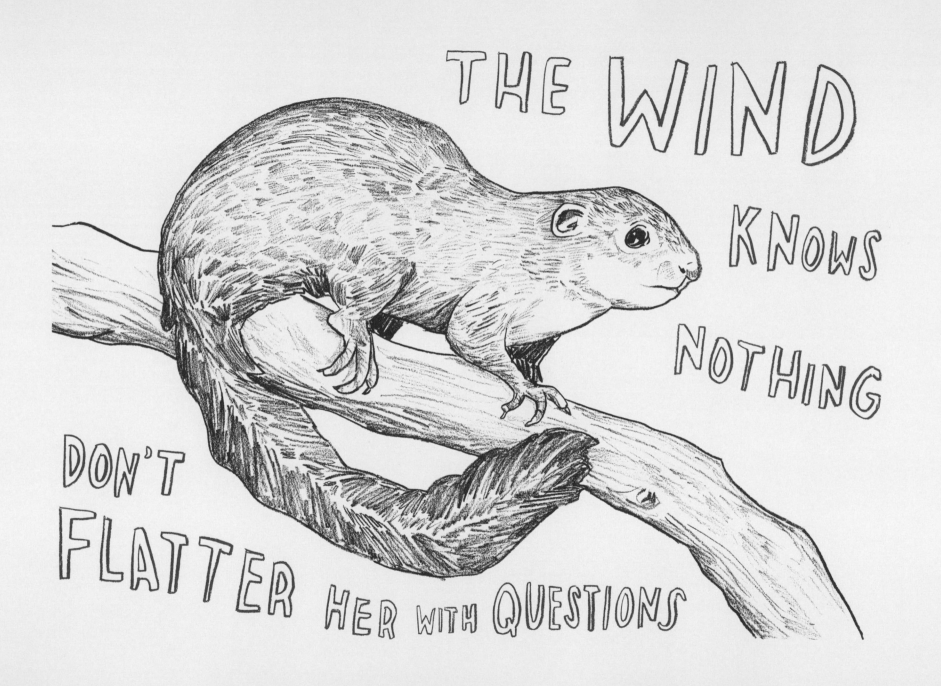

KING OF ASSHOLES

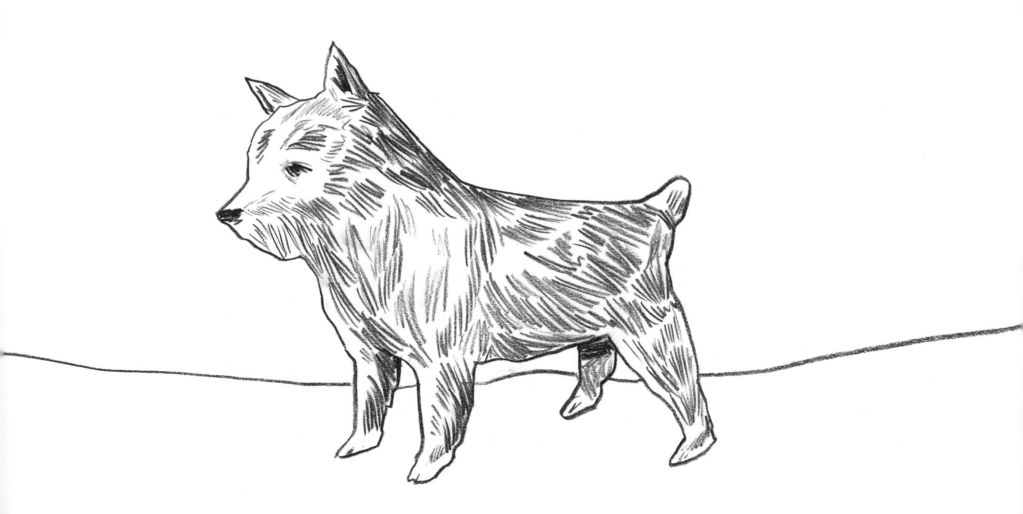

GLORY

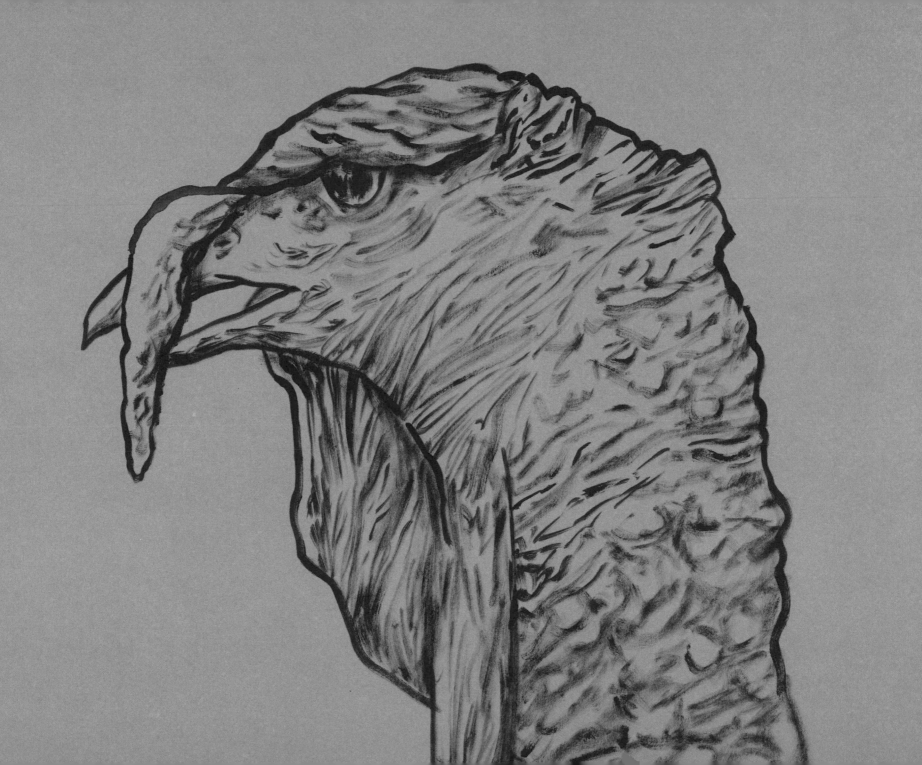

BUT THE MOON

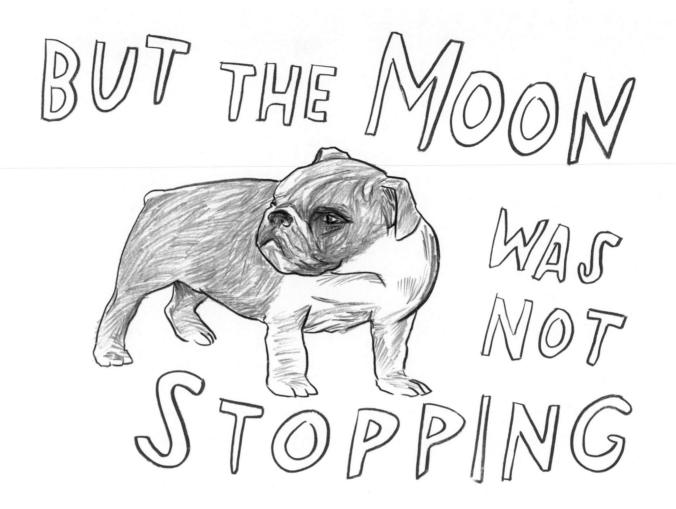

WAS NOT STOPPING

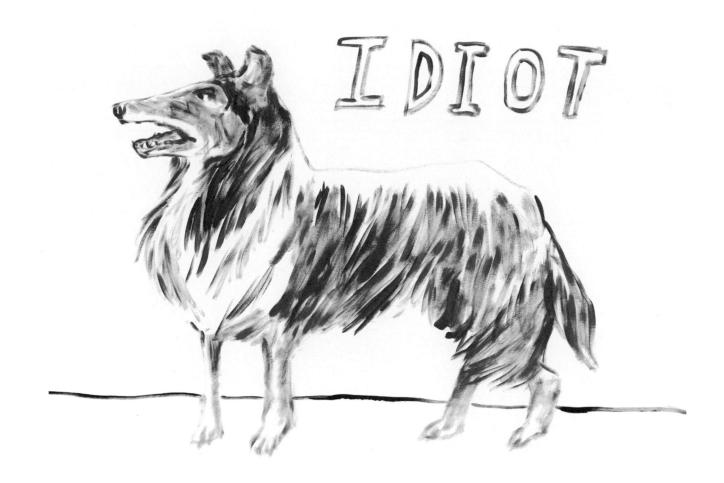

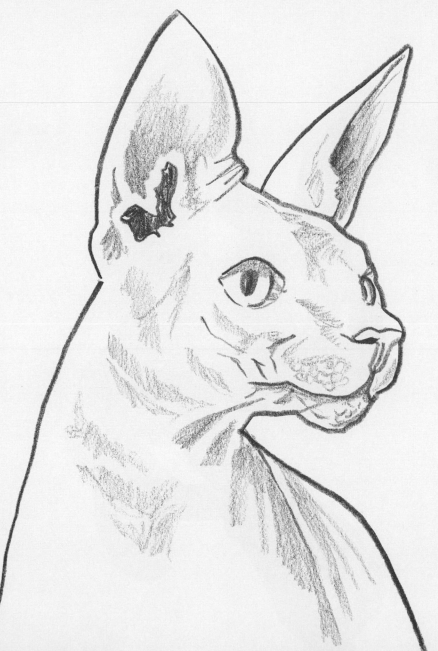

PYRRHIC

AT BEST

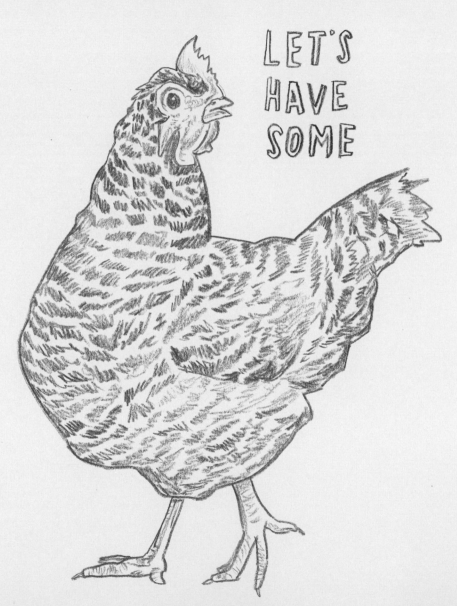

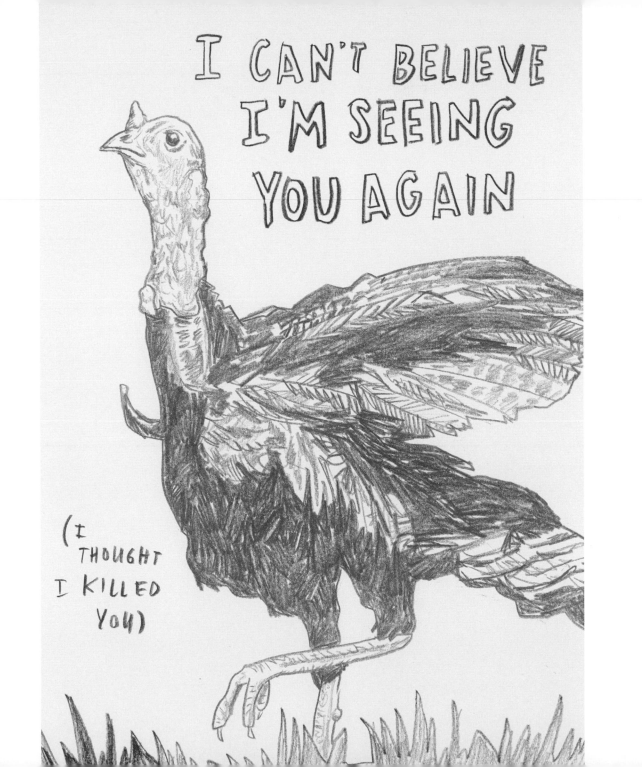

WOULD NOT WEEPING

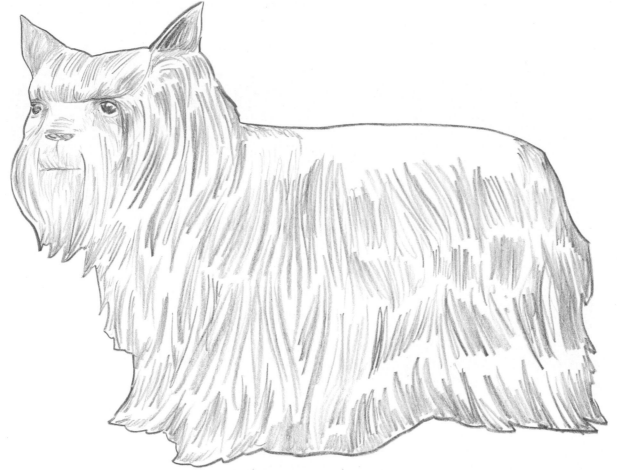

BE REDUNDANT?

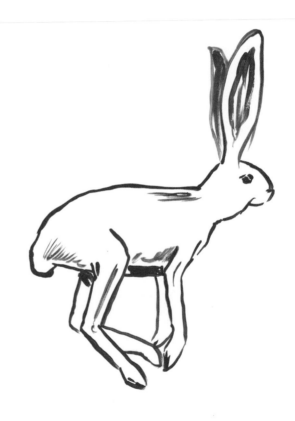

SPEED IS VIRTUE

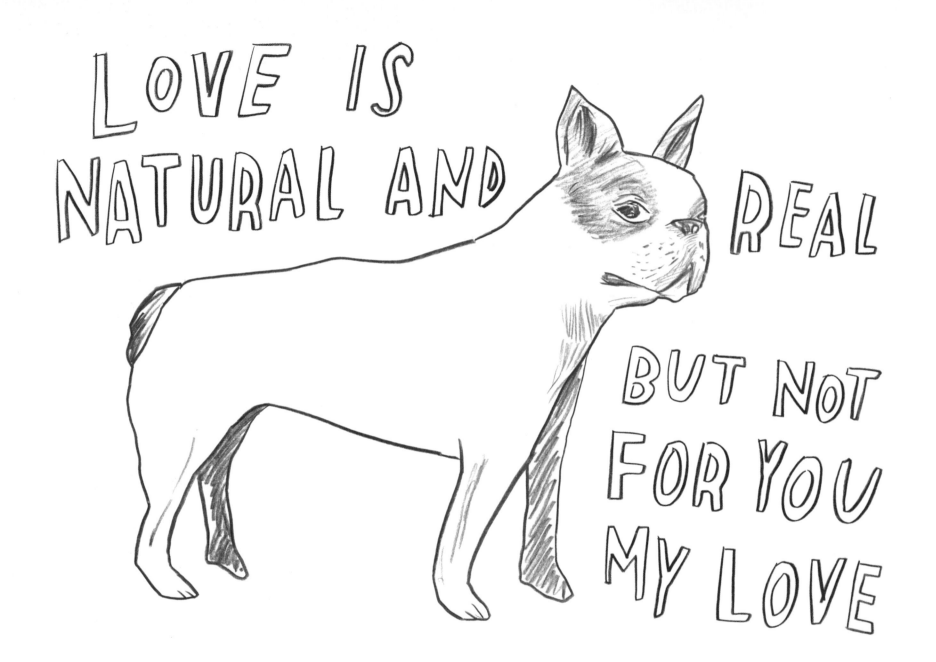

A FEAST IS MADE FOR LAUGHTER

BEHOLD, I WAS SHAPEN IN INIQUITY

HE ASKED WATER AND SHE GAVE HIM MILK

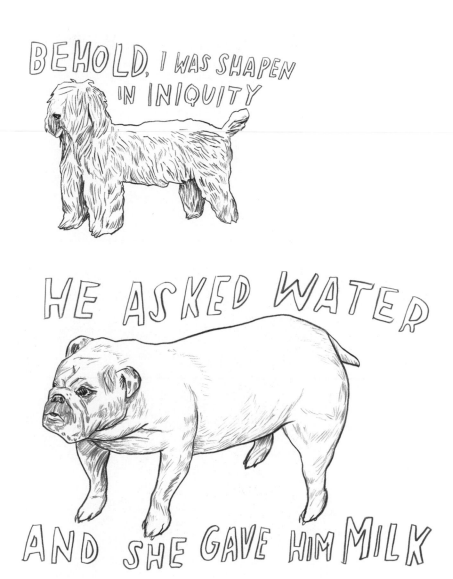

SPANIEL, SUSSEX

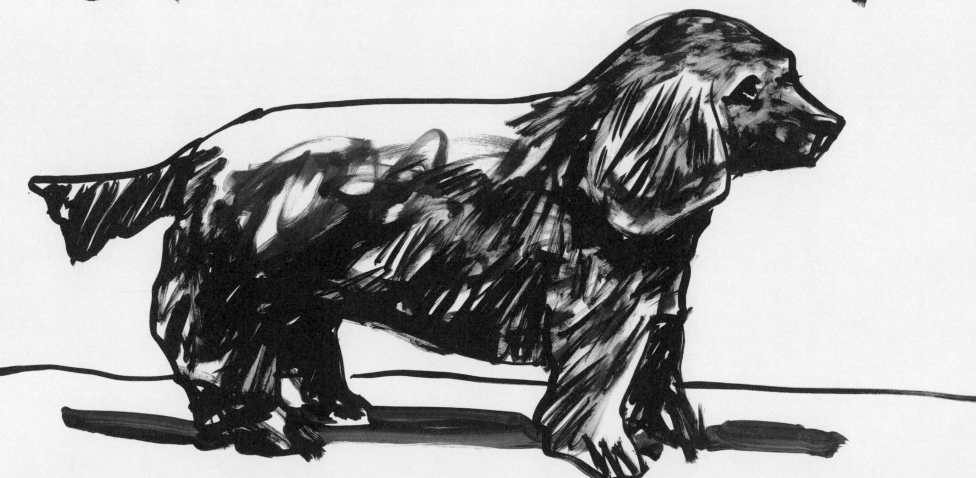

HAS NO STRONG OPINIONS ABOUT GREECE

AFFENPINSCHER

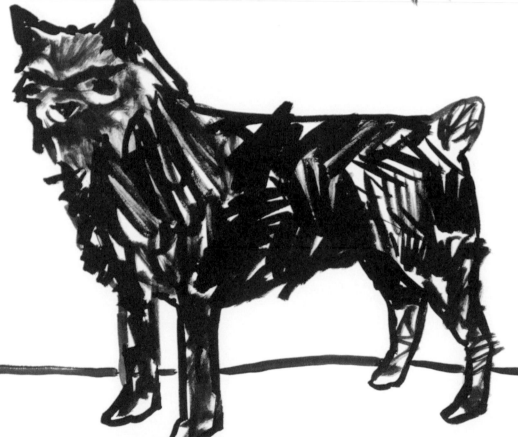

EMOTIONALLY UNAVAILABLE AT CRUCIAL TIMES

SOFT-COATED WHEATON TERRIER

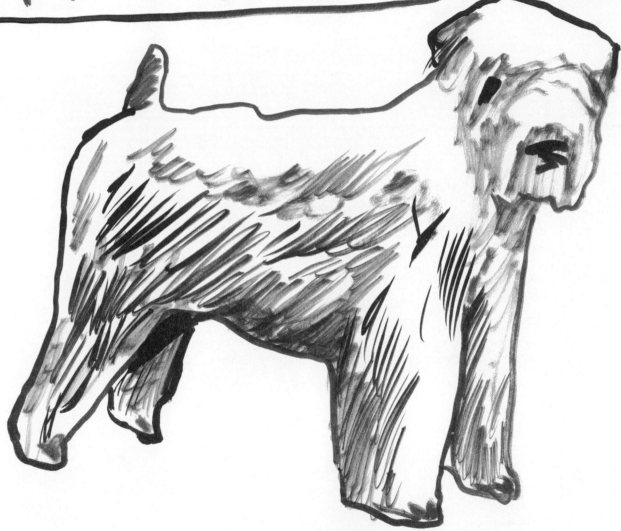

NOT LIKELY TO BE PART OF THE SOLUTION

SOFT-COATED GRIFFON

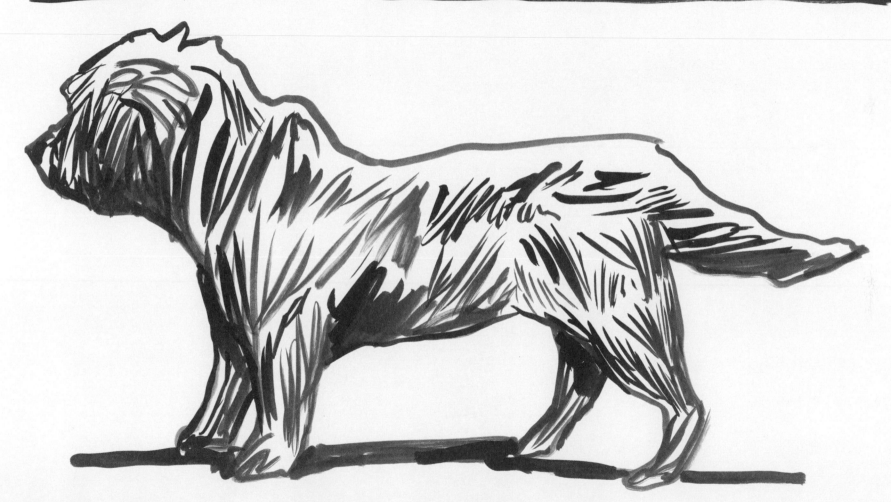

NEVER TRULY CARED ABOUT YOUR INSINCERITY

BORDER TERRIER

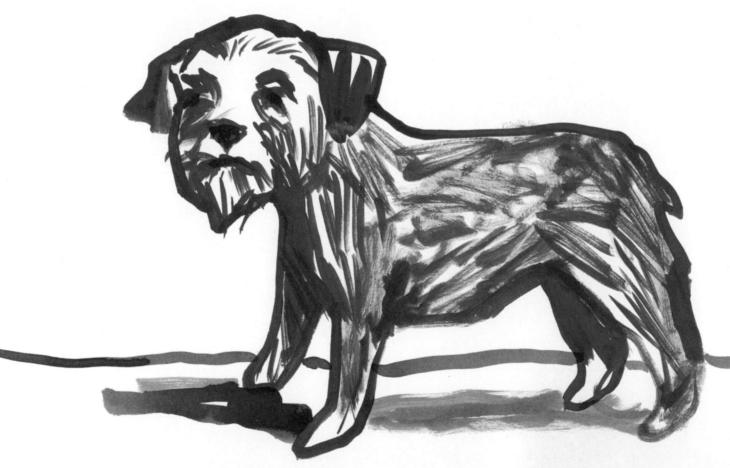

NOT A FACTOR IN 2016 OR 2020

SEALYHAM TERRIER

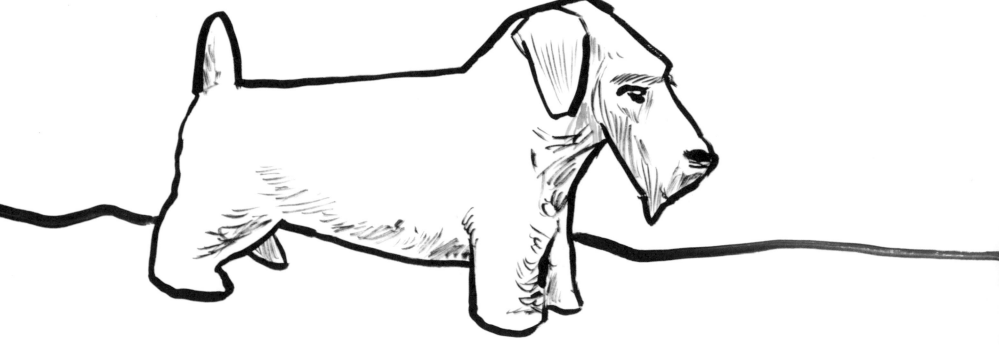

CLAIMS TO OUTMANUEVER SOROS "WITH STARTLING REGULARITY"

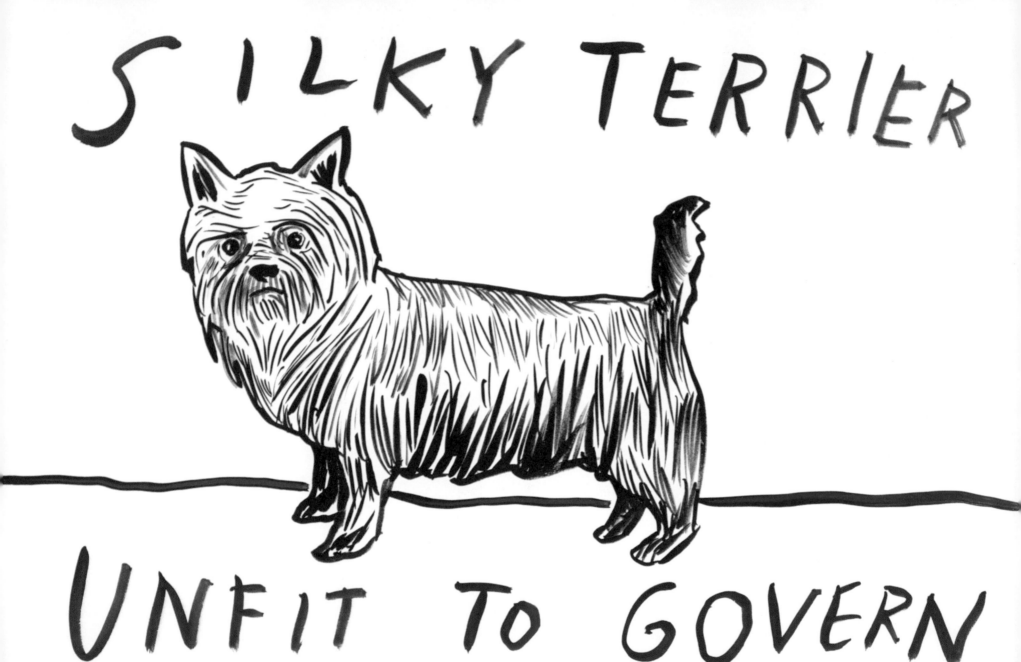

KLEINER MÜNSTERLÄNDER

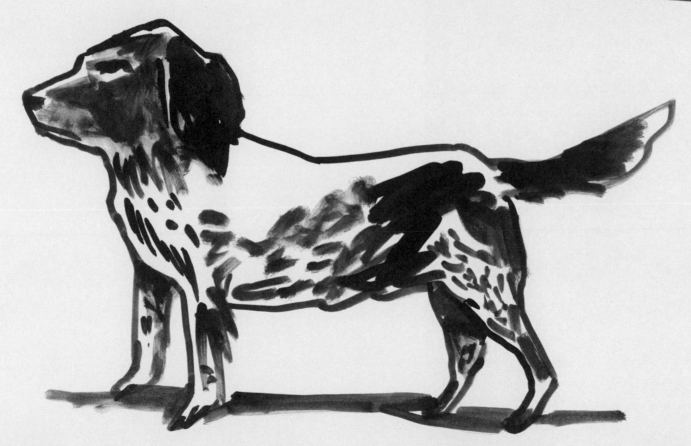

UNWILLING TO HELP YOU UNDERSTAND YOUR MOTHER

AND THE PARCHED LAND SHALL BECOME A POOL, AND THE THIRSTY LAND SPRINGS OF WATER: IN THE HABIT-ATION OF DRAGONS, WHERE EACH LAY, SHALL BE GRASS WITH REEDS AND RUSHES

DOOMED

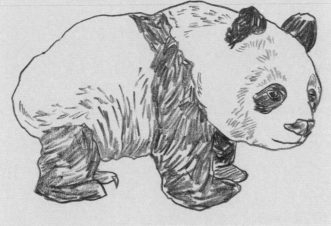

BY CHARM

ONLY HER DIARY KNOWS

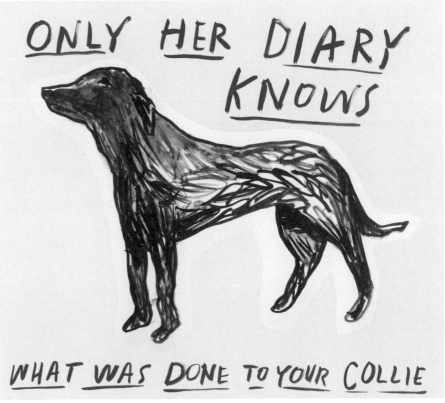

WHAT WAS DONE TO YOUR COLLIE

LIAR

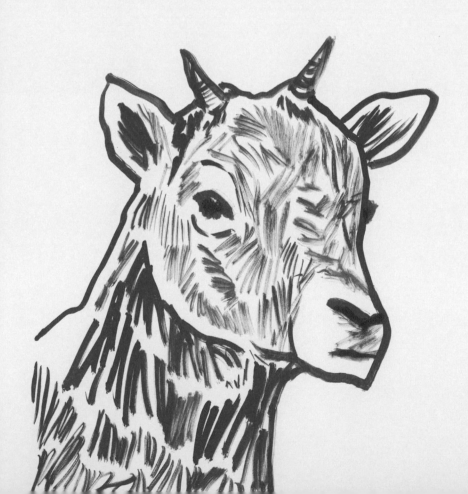

LOSER

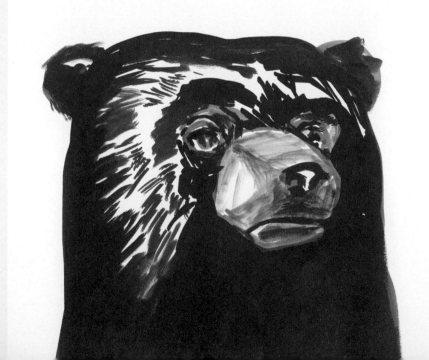

LOVER

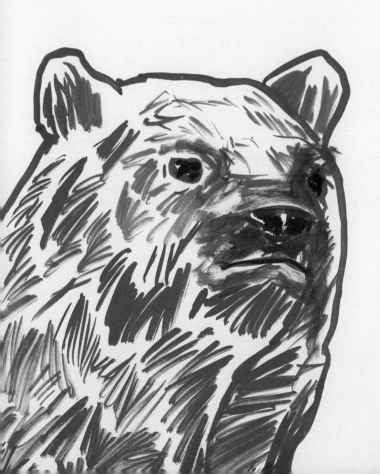

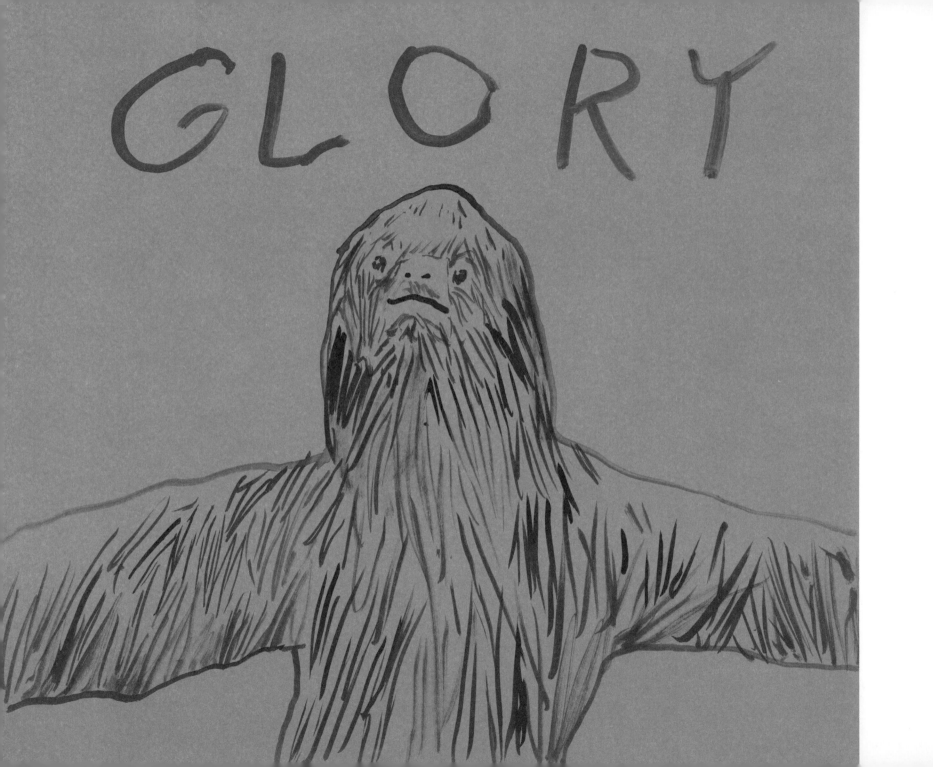

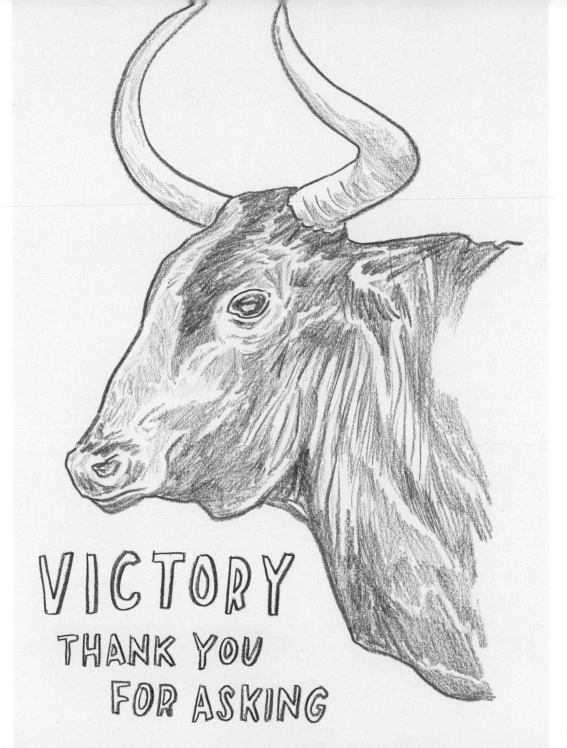

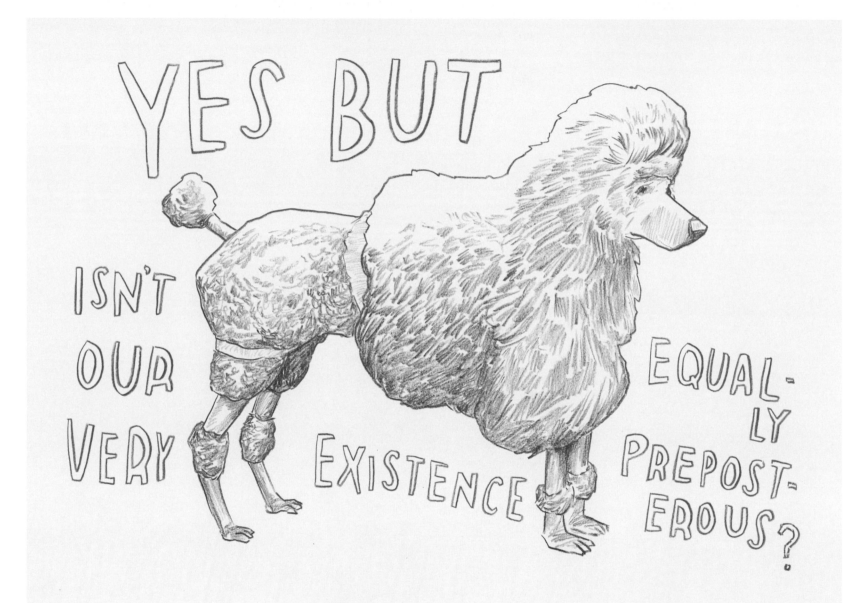

UNLIKELY

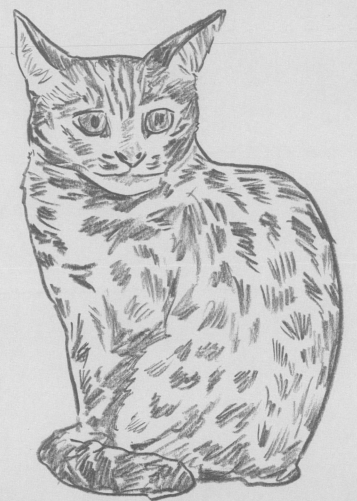

TO APOLOGIZE

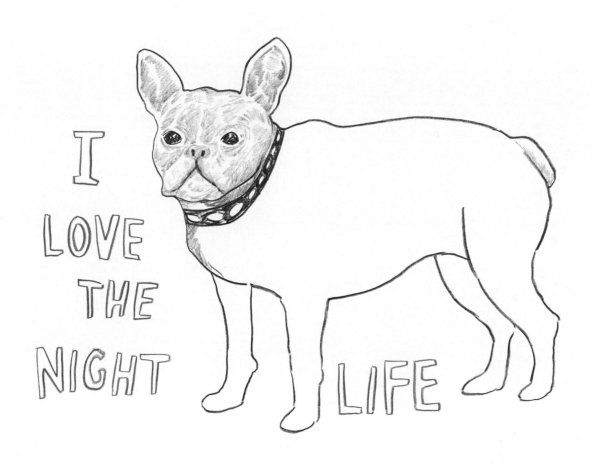

I LOVE THE NIGHT LIFE

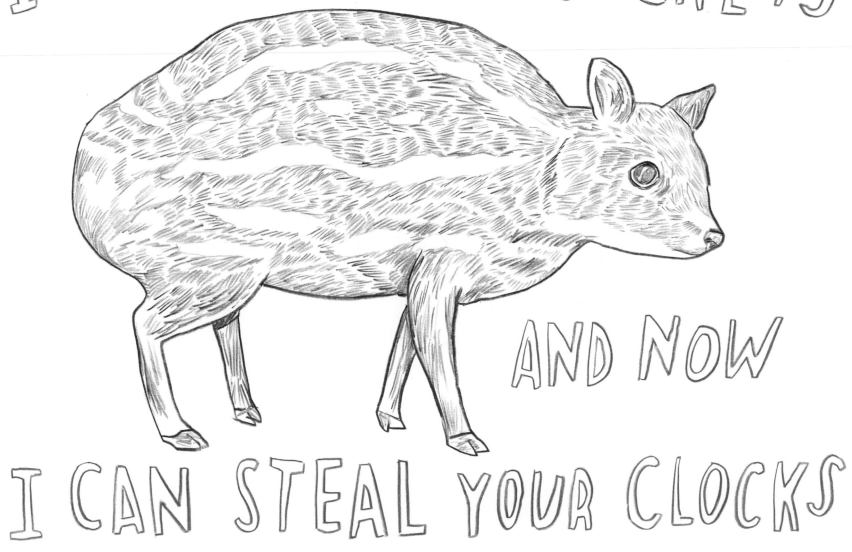

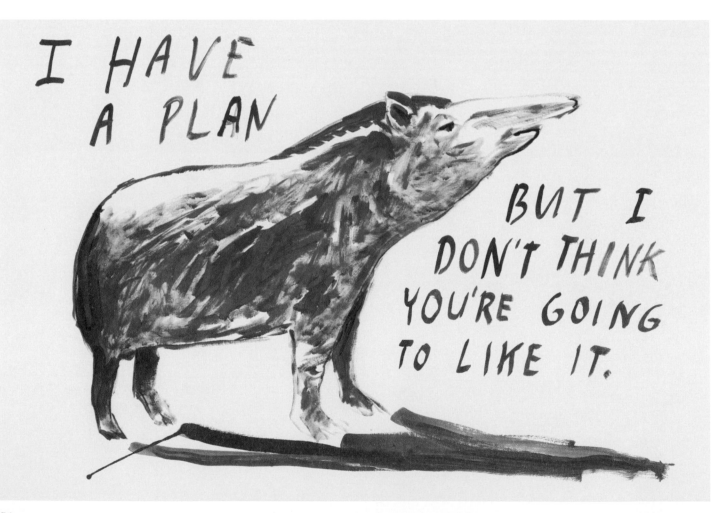

54

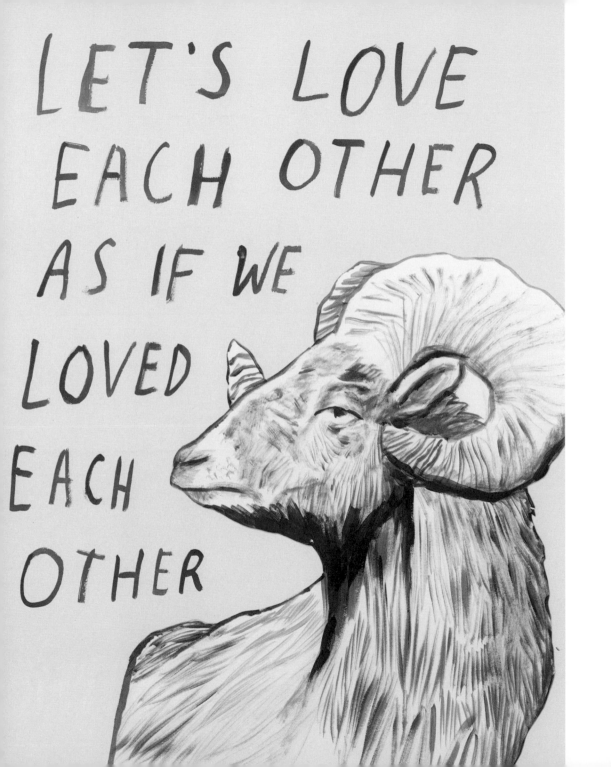

LET'S LOVE
EACH OTHER
AS IF WE
LOVED
EACH
OTHER

FOR THEE I STAND

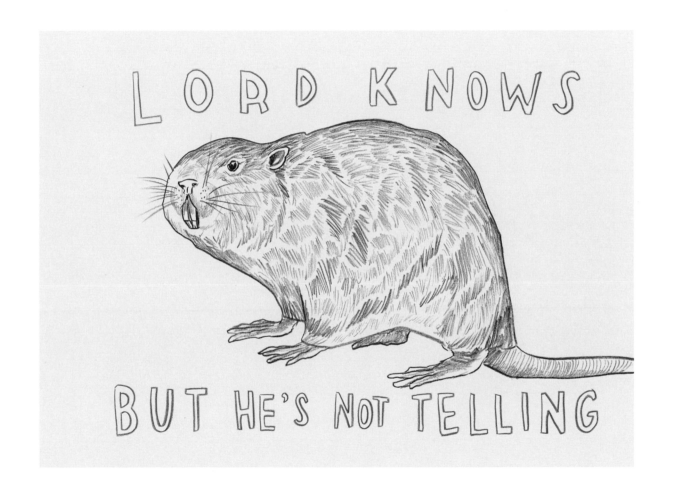

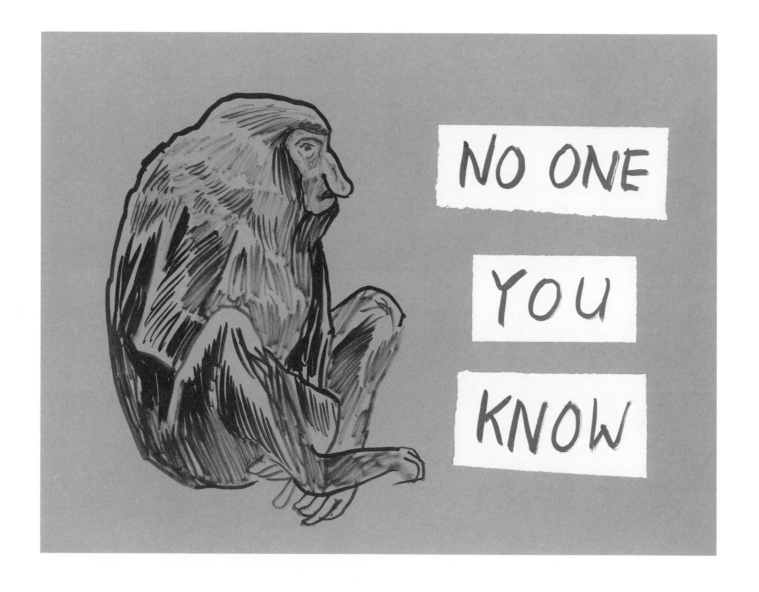

NOT MUCH OF A JOINER

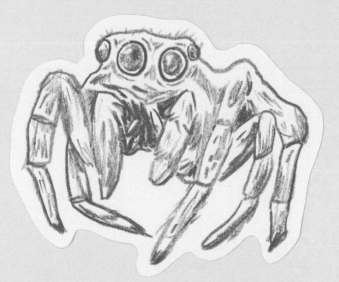

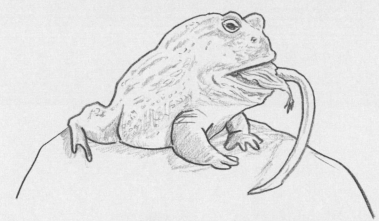

THERE ARE
TIMES WHEN

ONE THINKS
OF ROBESPIERRE

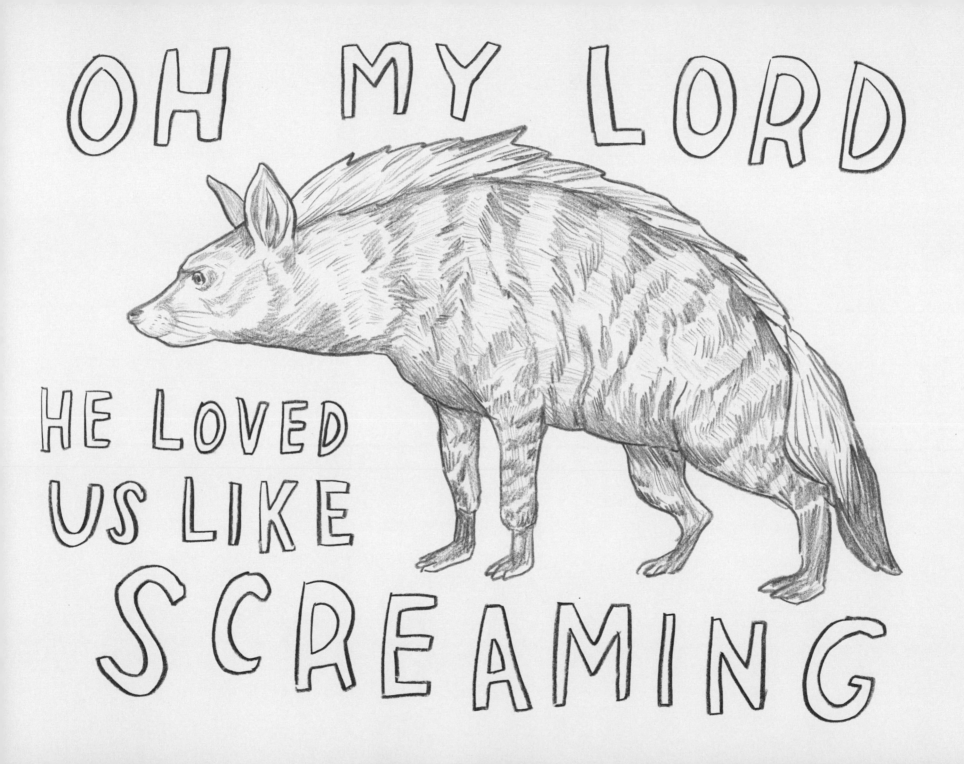

EVERYTHING IS SMALL

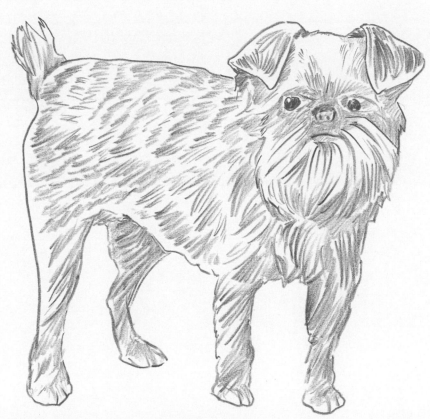

IN THE EYES OF GOD

ALSO I WILL ORDAIN A PLACE FOR MY PEOPLE

LOVE THOSE WHO TRY, BUT FAIL, TO MURDER YOU

STANDARD SCHNAUZER

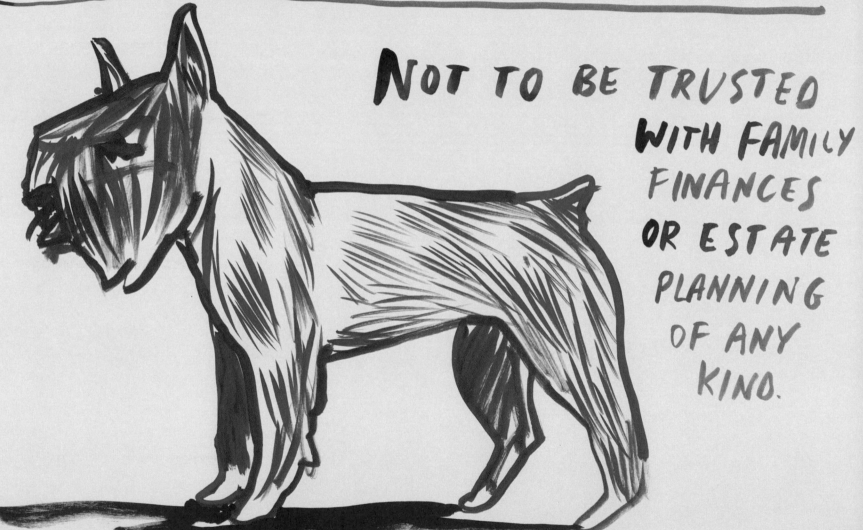

NOT TO BE TRUSTED WITH FAMILY FINANCES OR ESTATE PLANNING OF ANY KIND.

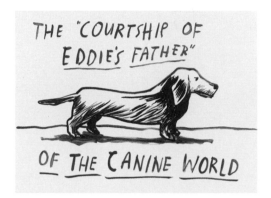

THE "COURTSHIP OF EDDIE'S FATHER" OF THE CANINE WORLD

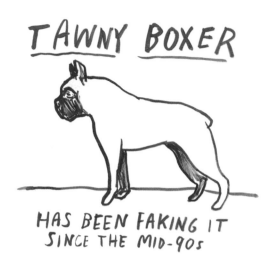

TAWNY BOXER

HAS BEEN FAKING IT SINCE THE MID-90s

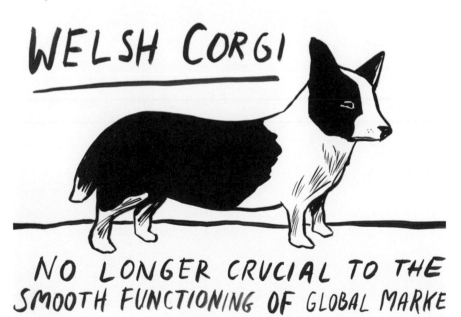

WELSH CORGI

NO LONGER CRUCIAL TO THE SMOOTH FUNCTIONING OF GLOBAL MARKE

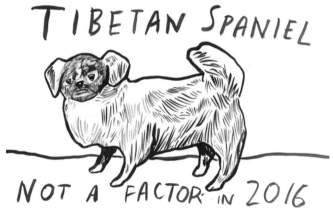

TIBETAN SPANIEL

NOT A FACTOR IN 2016

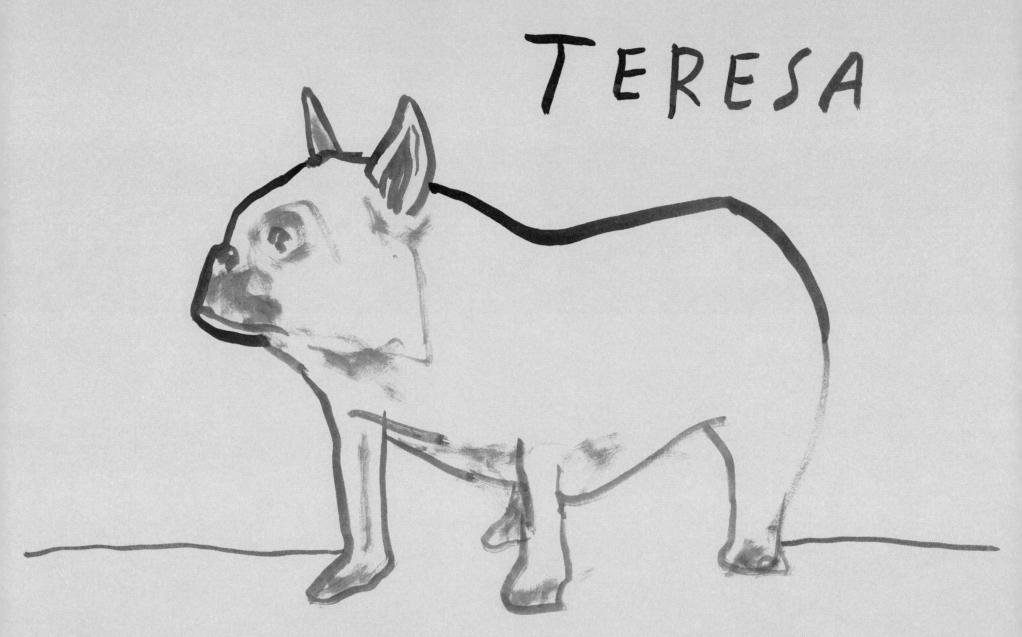

TERESA

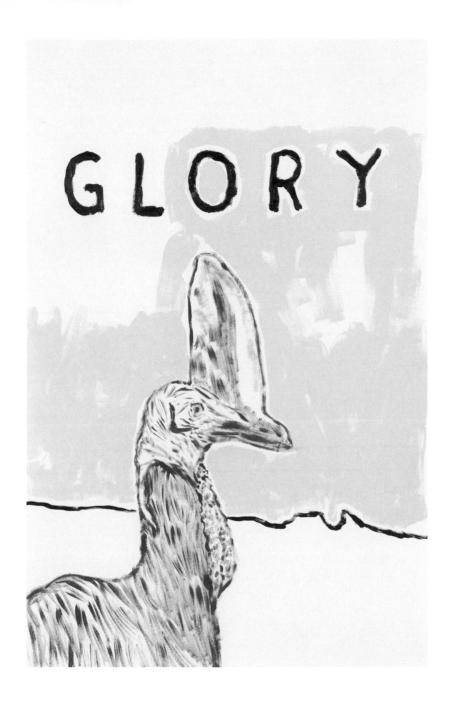

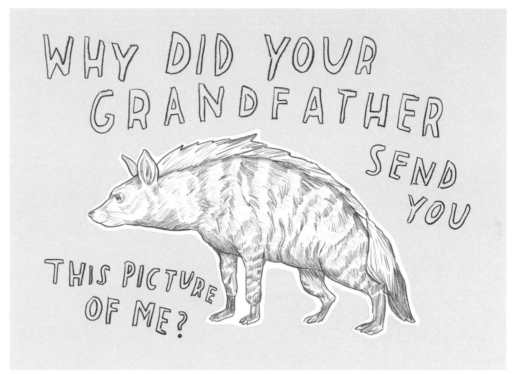

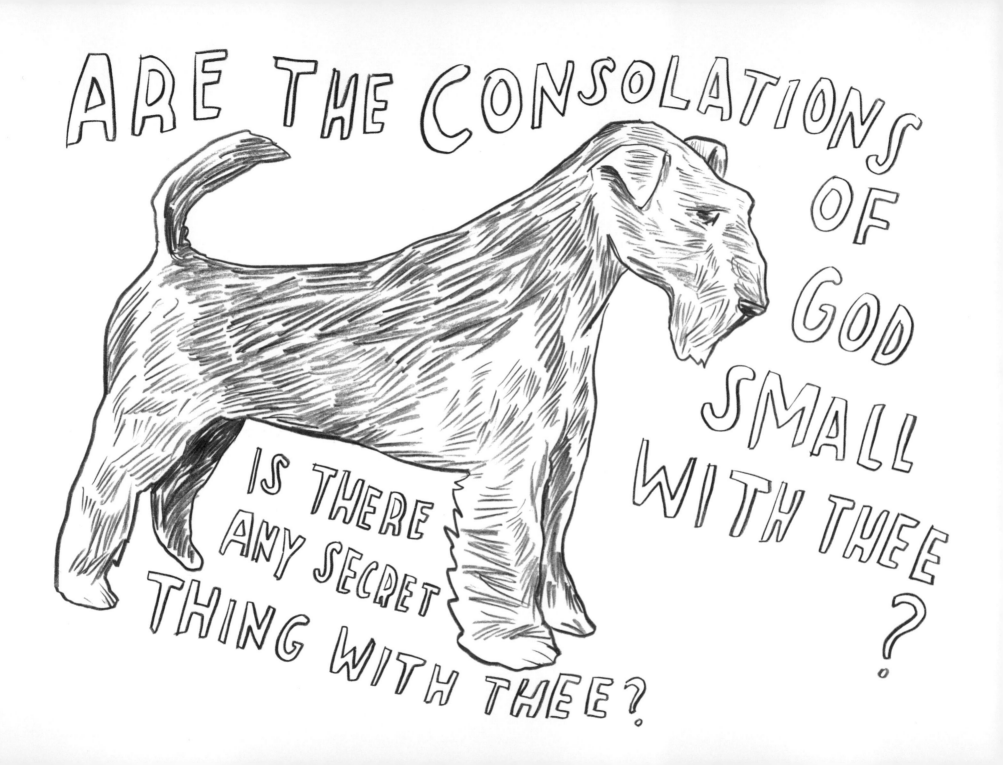

ASIATIC CHEVROTAIN

THE CADILLAC OF SMALL ARTIO-DACTYLS

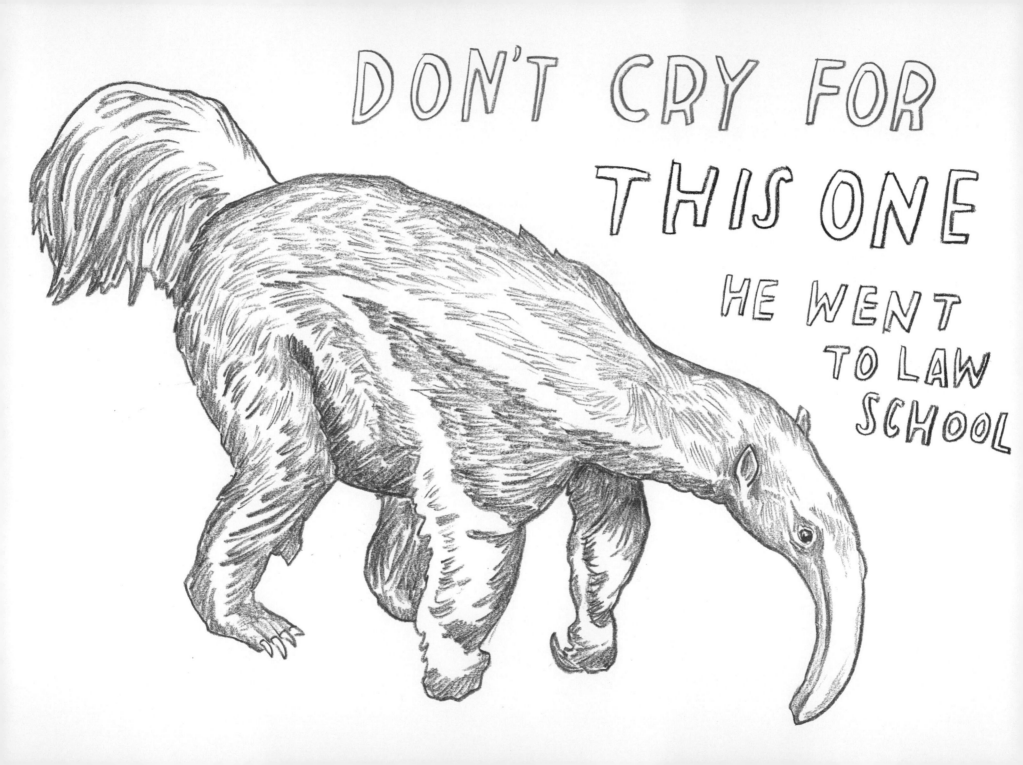

DON'T CRY FOR THIS ONE HE WENT TO LAW SCHOOL

GIVE ME AN EXAMPLE OF RECENT AND EFFECTIVE EUROZONE REGULATORY ACTION

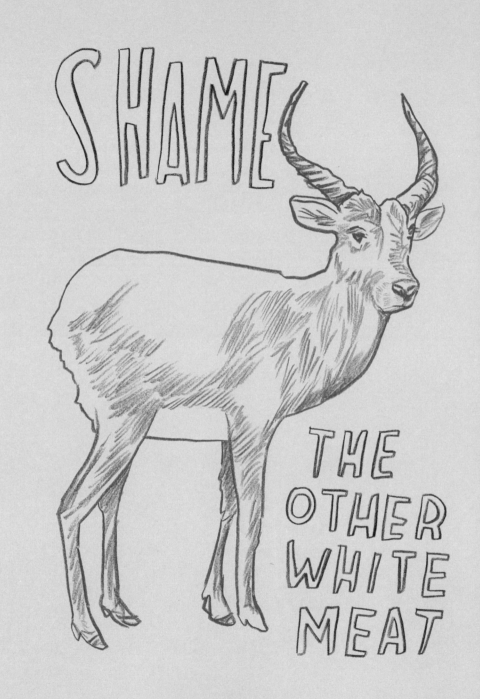

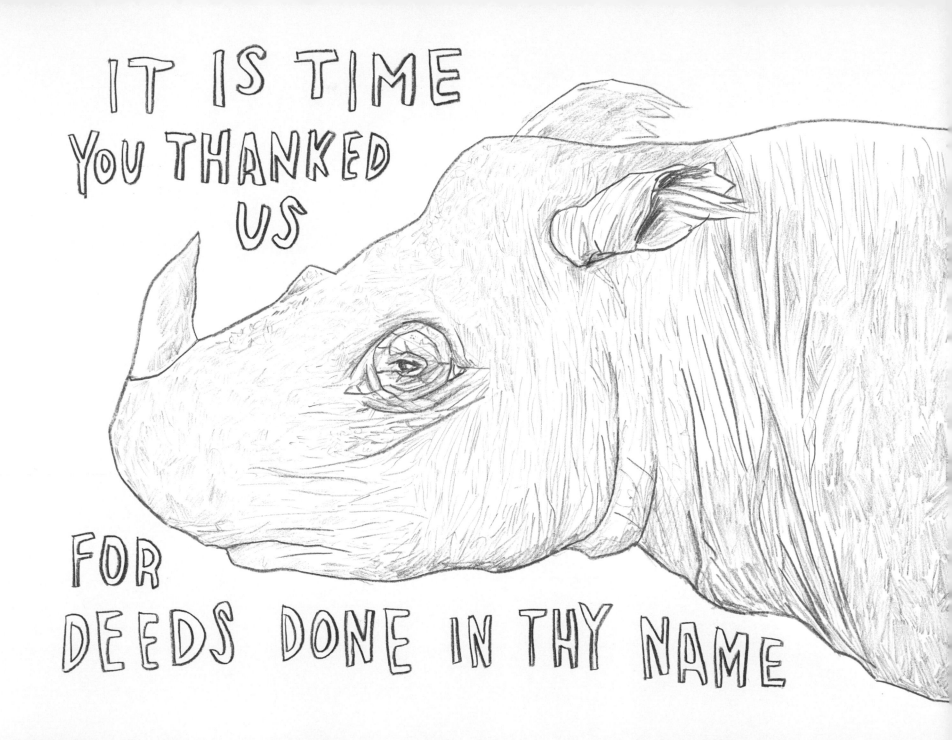

I'M SO GLAD YOU NOTICED THAT MY FLESH CAN BE EATEN

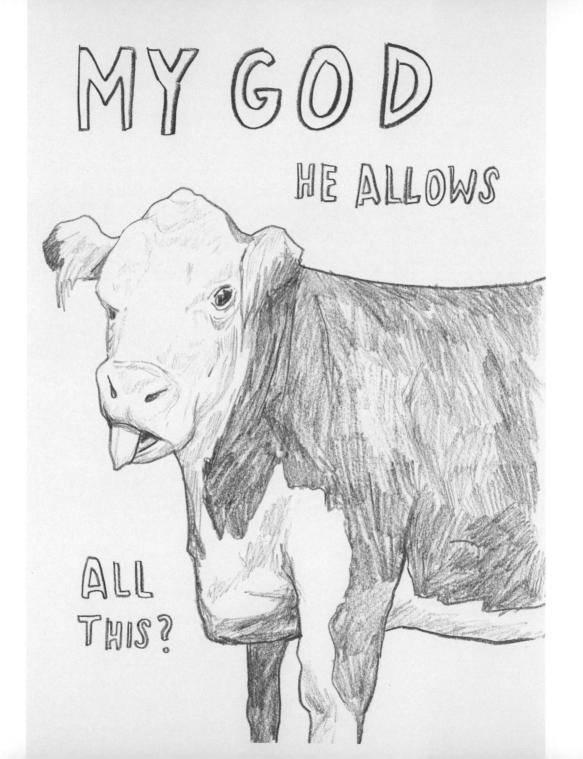

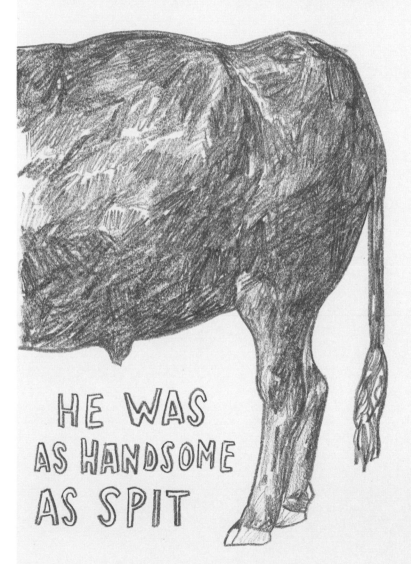

MY GOD

HE WAS
AS HANDSOME
AS SPIT

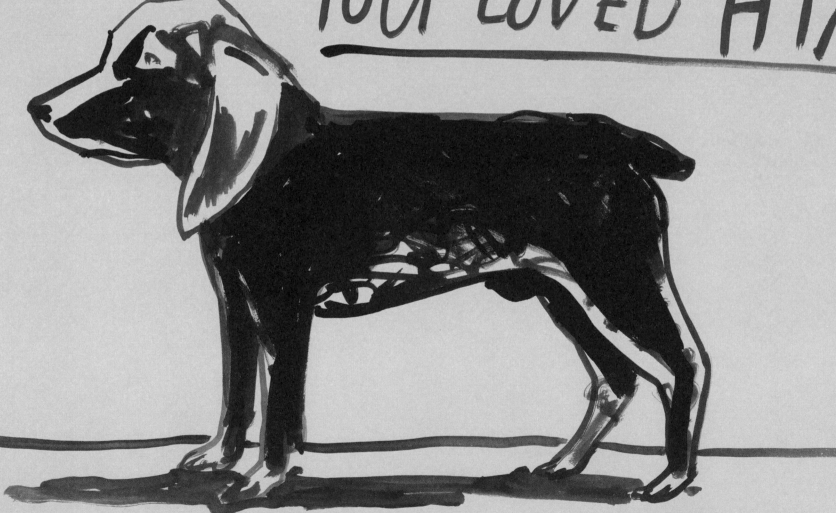

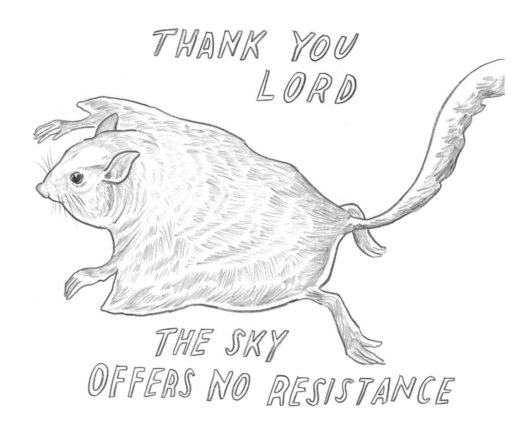

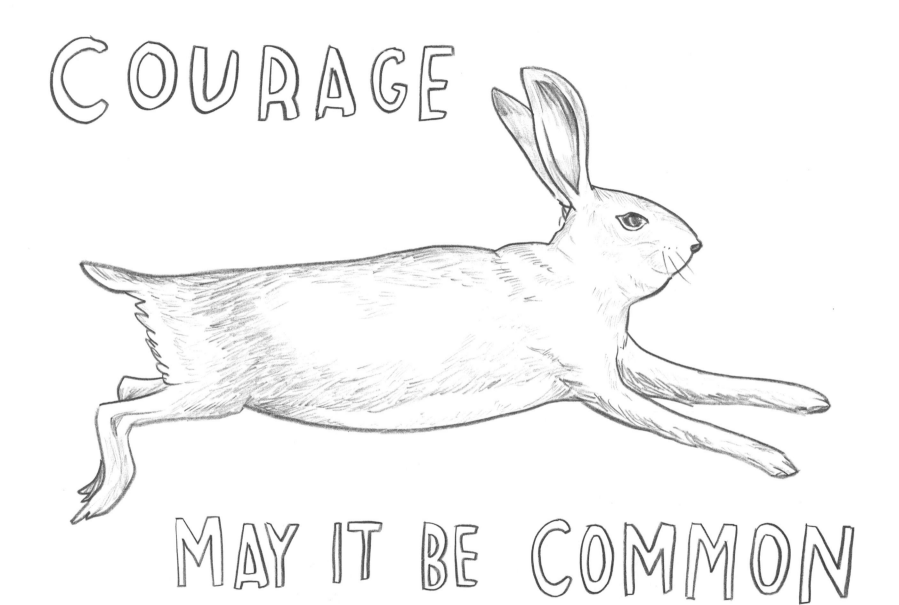

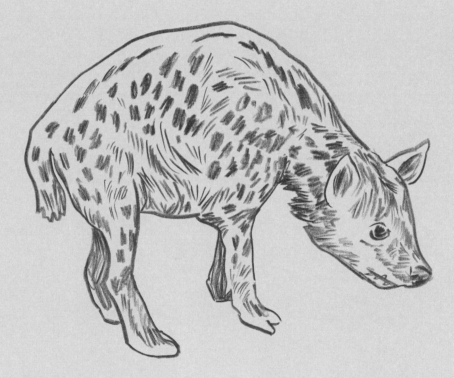

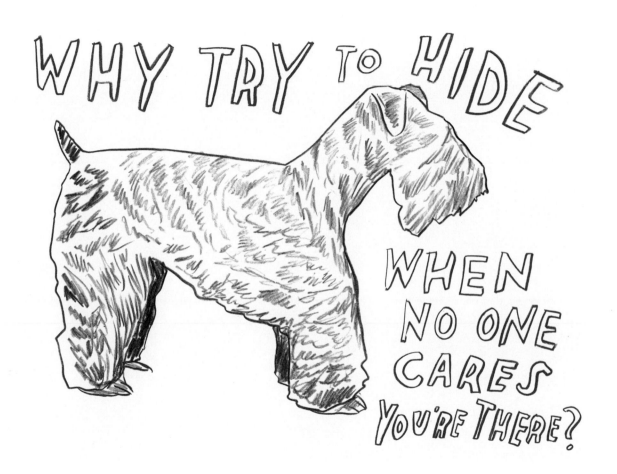

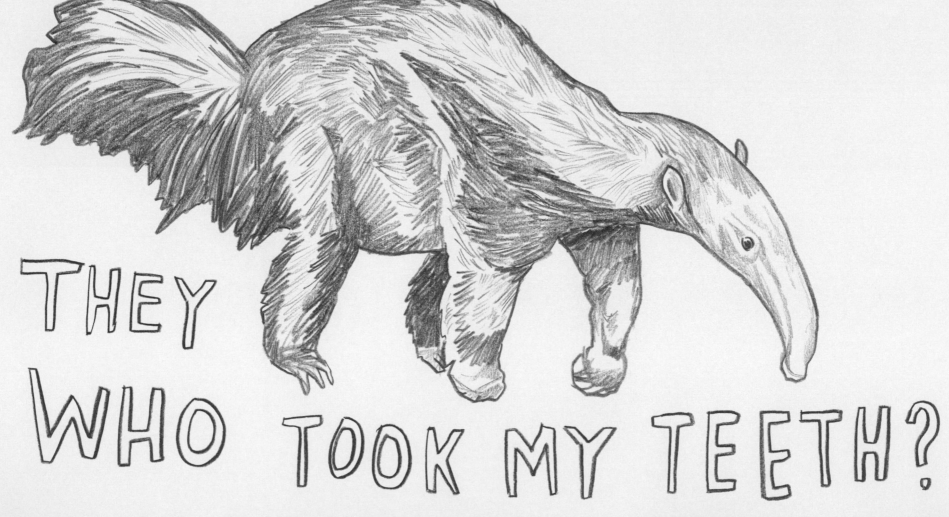

LORD MUST I LOVE

THEY WHO TOOK MY TEETH?

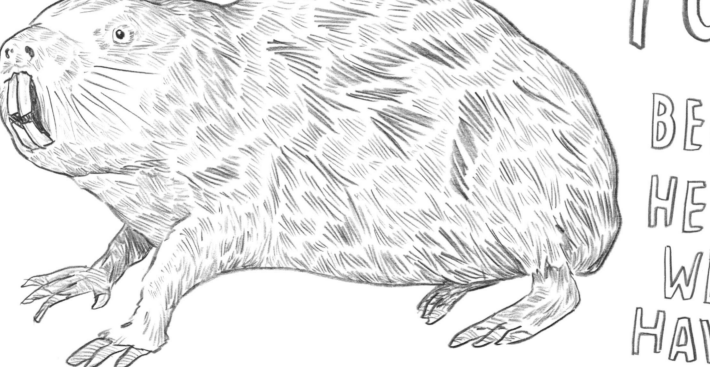

GO TO, LET US GO DOWN, AND THERE CONFOUND THEIR LANGUAGE

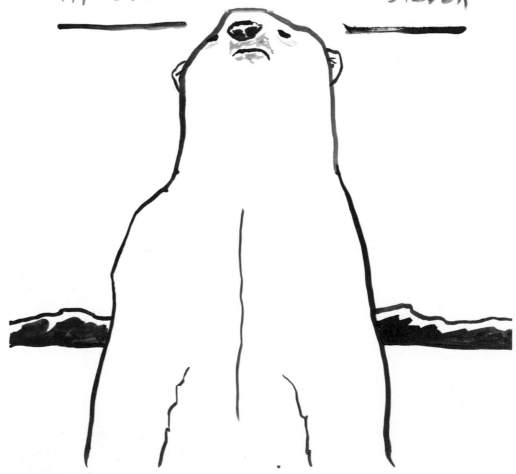

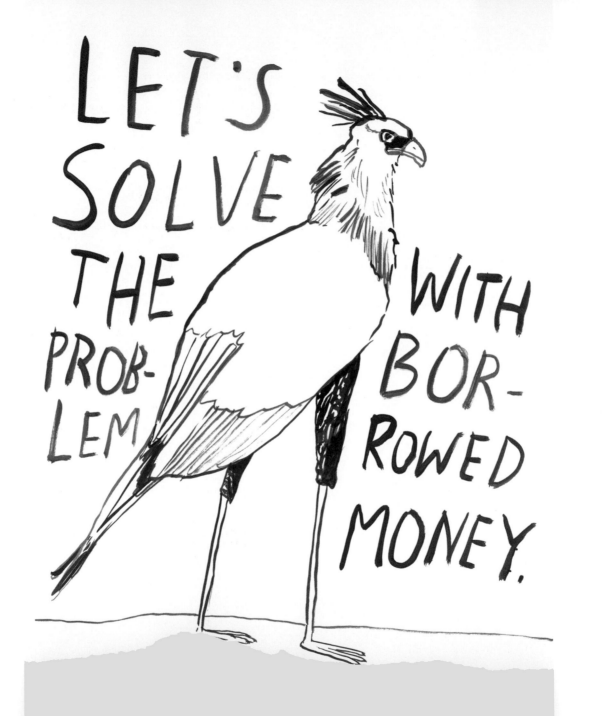

LET'S SOLVE THE PROB-LEM WITH BOR-ROWED MONEY.

TIPSY
LADY

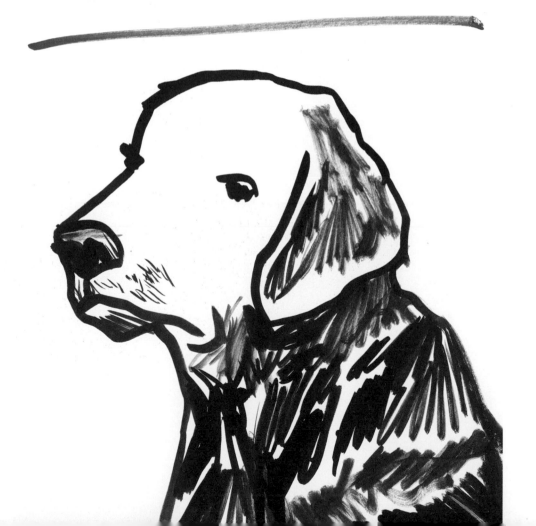

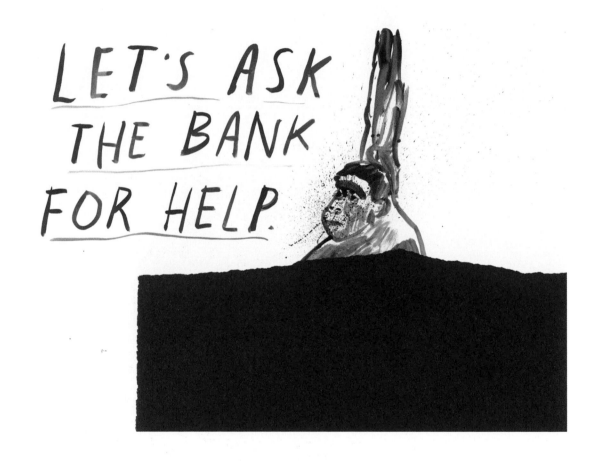

HA HA HA HA HA HA

HA HA HA HA

HA HA HA HA HA

IT WAS IT FELT

FORE- SO GOOD.

SEEN

GLORY

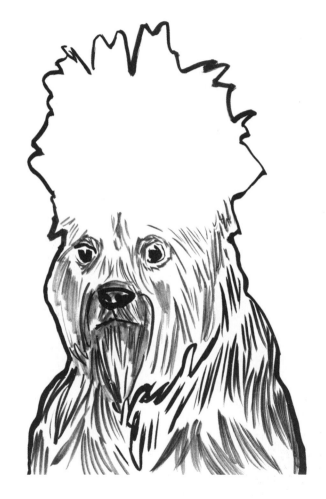

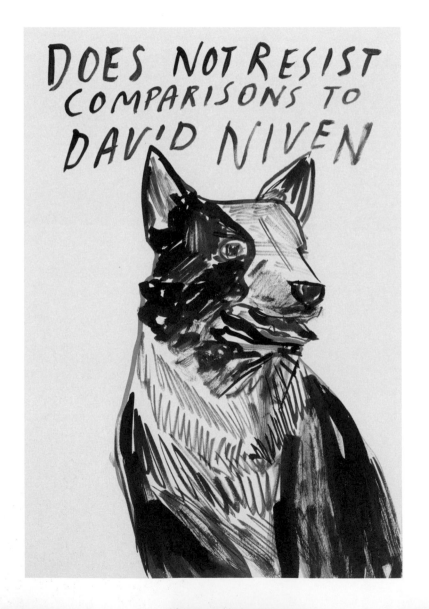

DOES NOT RESIST COMPARISONS TO DAVID NIVEN

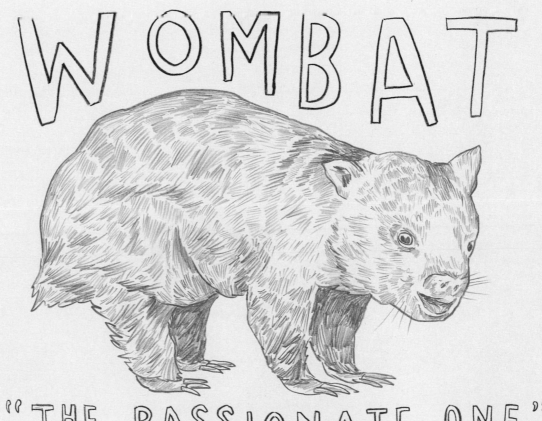

WOMBAT

"THE PASSIONATE ONE"

AUSTRALIAN CATTLE DOG

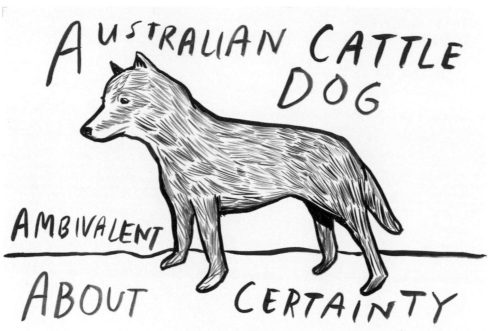

AMBIVALENT ABOUT CERTAINTY

NO ONE HAS SUCCESFULLY FUCKED SCREWED WITH

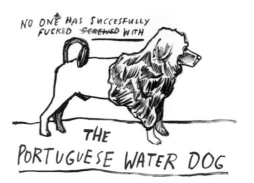

THE PORTUGUESE WATER DOG

RETRIEVER, FLAT-COATED

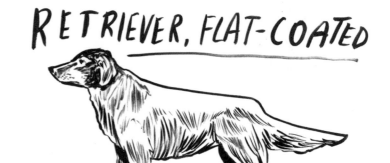

UNWILLING TO ENGAGE ON CURRENCY REFORM

BERGAMASCO

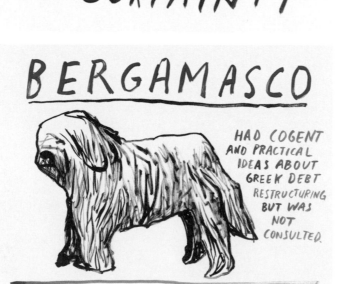

HAD COGENT AND PRACTICAL IDEAS ABOUT GREEK DEBT RESTRUCTURING BUT WAS NOT CONSULTED.

UNCOMFORTABLE WITH AUTHORITY

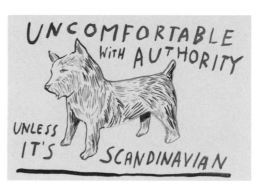

UNLESS IT'S SCANDINAVIAN

AFFENPINCHER

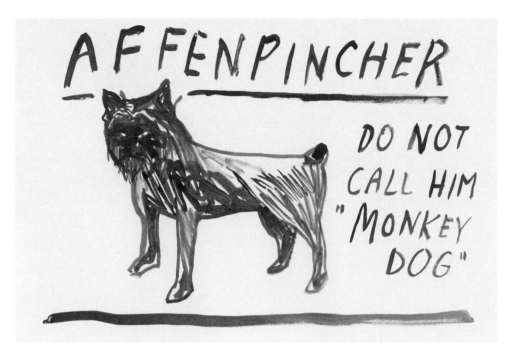

DO NOT CALL HIM "MONKEY DOG"

OTTER HOUND

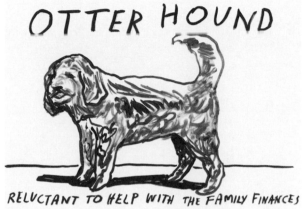

RELUCTANT TO HELP WITH THE FAMILY FINANCES

SMOOTH DACHSHUND

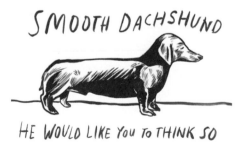

HE WOULD LIKE YOU TO THINK SO

WIREHAIRED POINTING GRIFFON

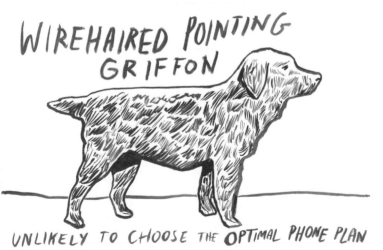

UNLIKELY TO CHOOSE THE **OPTIMAL PHONE PLAN**

BEARDED COLLIE

ENEMY OF ELEGANCE

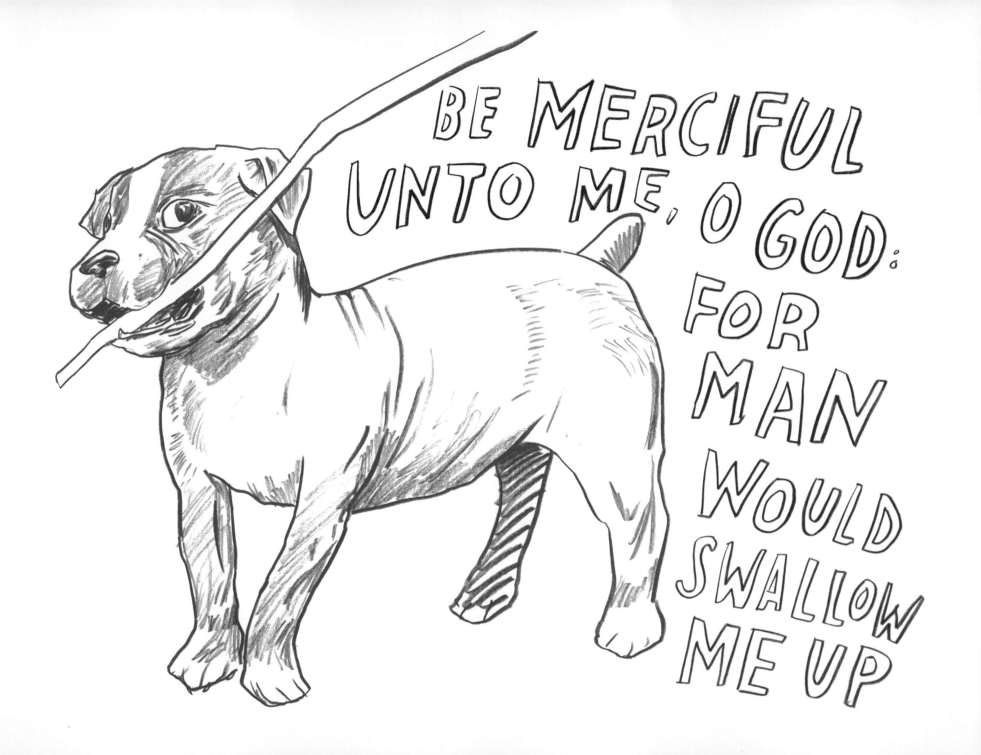

CLUMBER SPANIEL

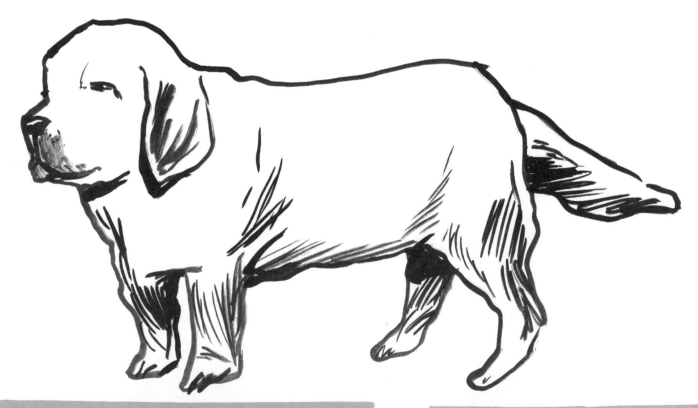

PEERLESS IN HIS CAPACITY FOR RANCOR & DISCHORD

IT'S OKAY IT'S OKAY IT'S OKAY

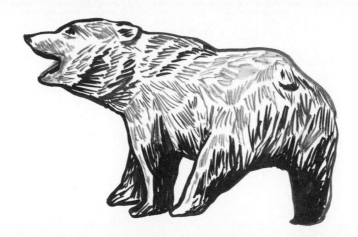

I CLEARED ALL THIS WITH JULIAN

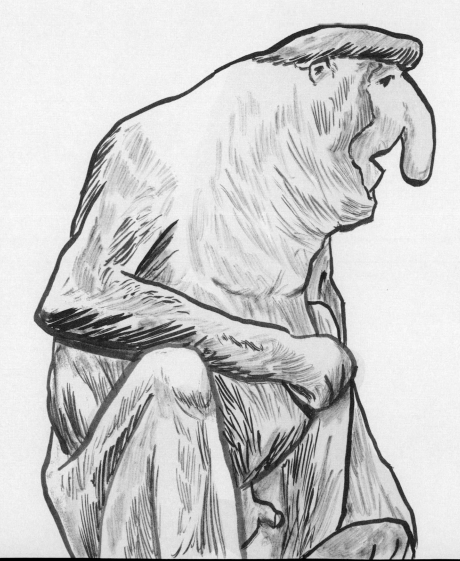

I HAVE
DIGGED
AND DRUNK
STRANGE
WATERS

MASTIFF: OPEN TO SUGG-ESTION

ROMANCE

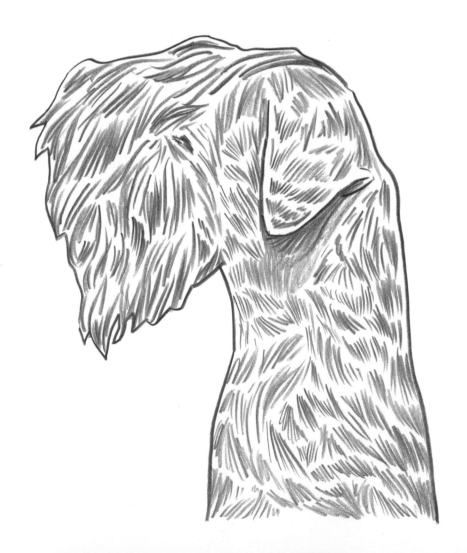

FASCINATED BY

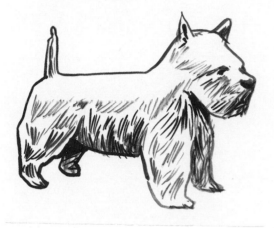

YOUR FATUOUS BULLSHIT

OH MY 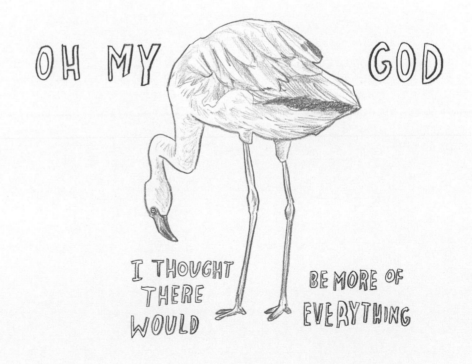 GOD

I THOUGHT
THERE
WOULD

BE MORE OF
EVERYTHING

PATAGONIAN CAVY

THERE IS NO SUBSTITUTE

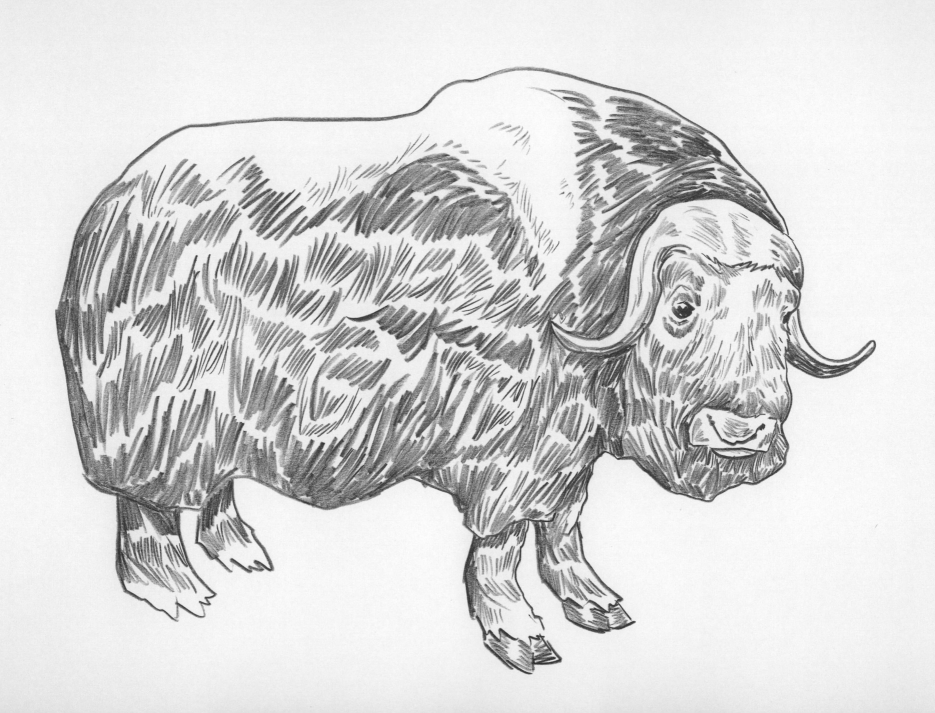

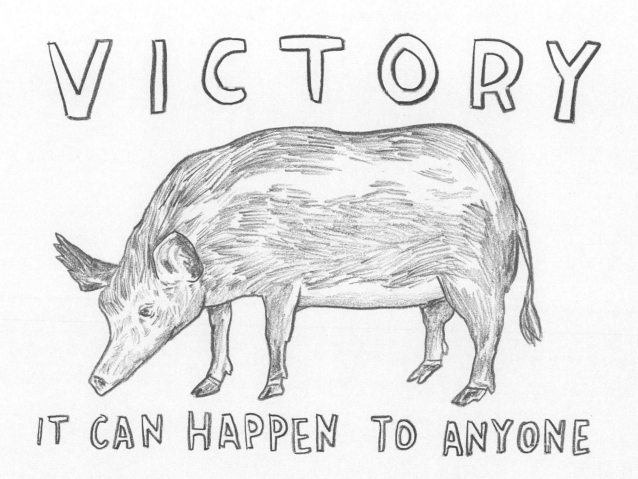

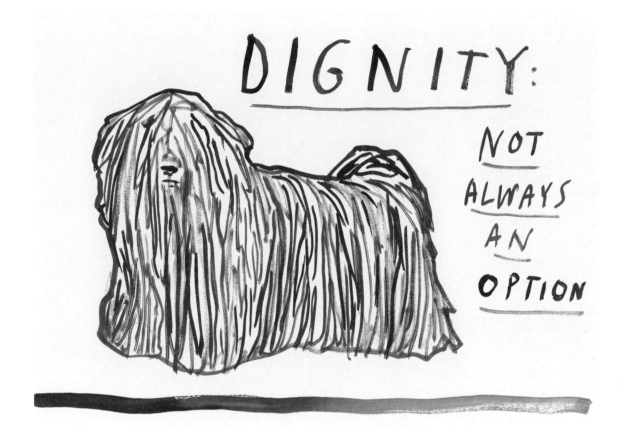

DIGNITY:

NOT ALWAYS AN OPTION

THE WAY OF MAN IS FROWARD AND STRANGE: BUT AS FOR THE PURE, HIS WORK IS RIGHT.

NOT QUITE DIGNITY BUT BETTER THAN ENNUI

IT'S TIME TO BREAK THIS WIDE OPEN

THE PULI: IT'S OKAY TO LAUGH

"THE MODERN CHIHUAHUA IS NOT FITTED FOR A STRUGGLE FOR EXISTENCE IN THE MEXICAN DESERT

WEST HIGHLAND WHITE TERRIER

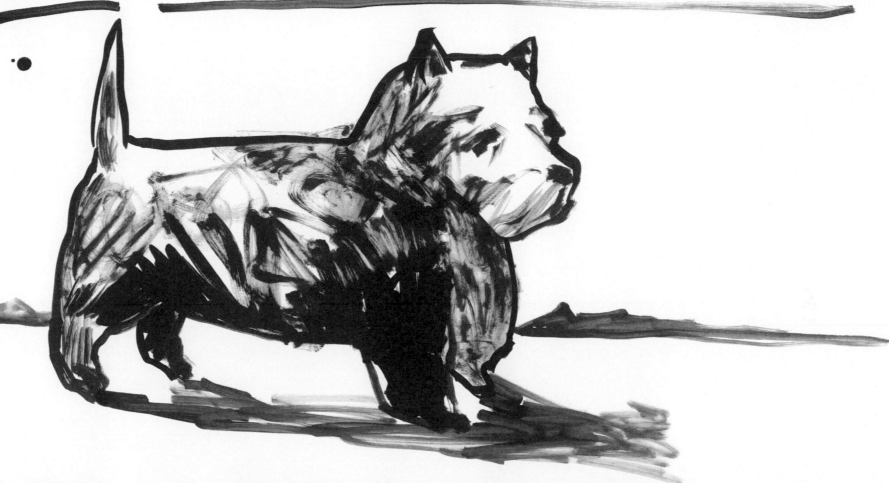

HAPPY TO BEAR ALL THE WORLD'S WOE

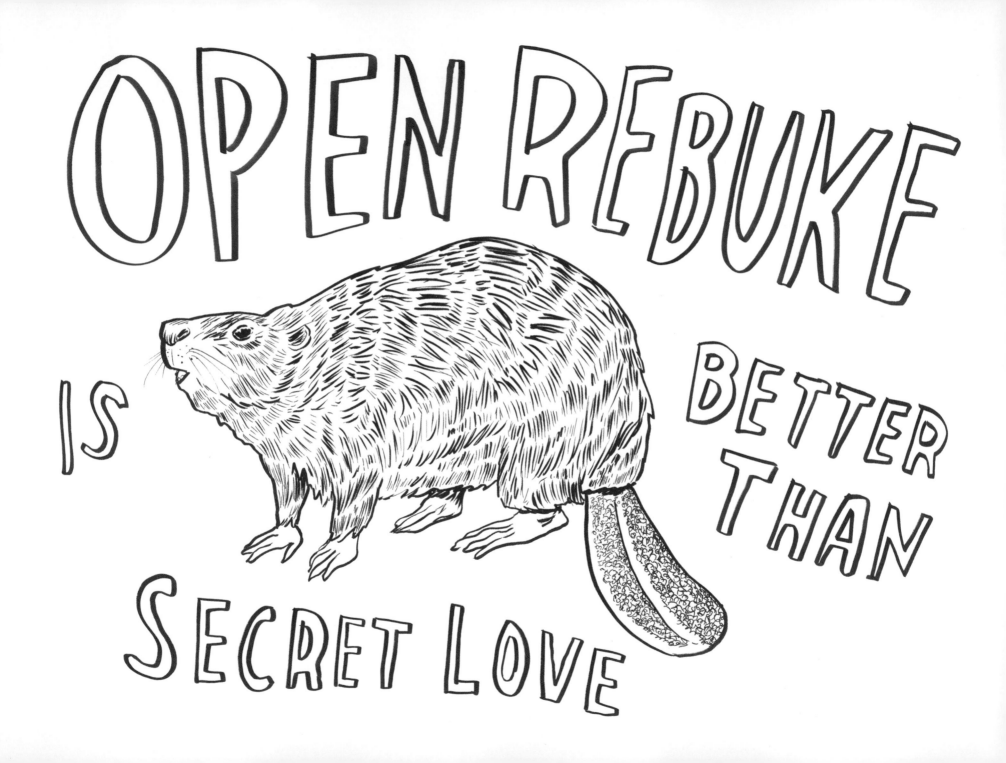

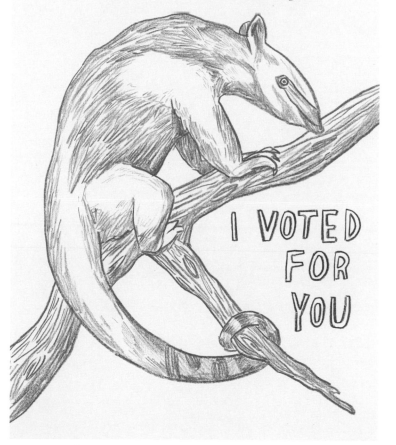

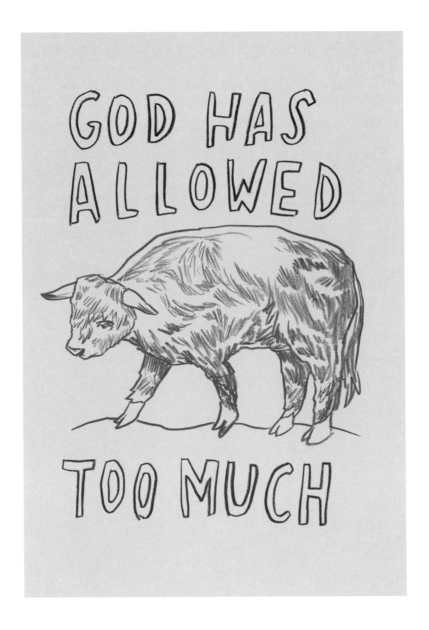

A MAN SHALL EAT GOOD BY THE FRUIT OF HIS MOUTH: BUT THE SOUL OF THE TRANSGRESSORS SHALL EAT VIOLENCE

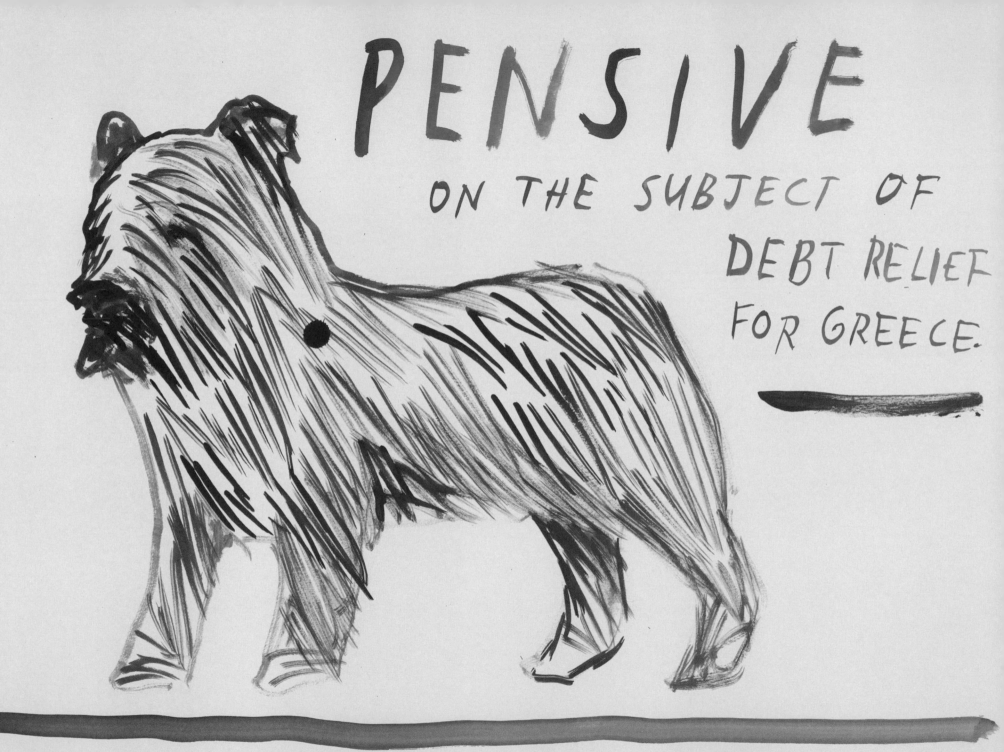

PENSIVE

ON THE SUBJECT OF
DEBT RELIEF
FOR GREECE.

HAS NO REGRETS ABOUT NEWARK

BUT IS WAVERING ON TAMPA

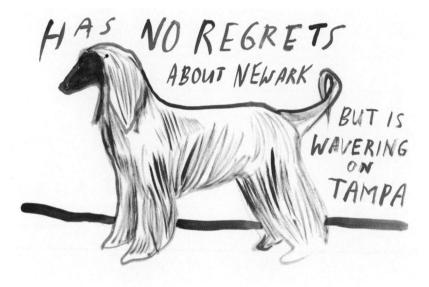

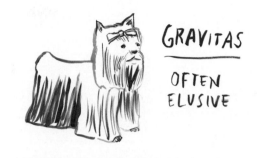

GRAVITAS
OFTEN ELUSIVE

LLASA APSO

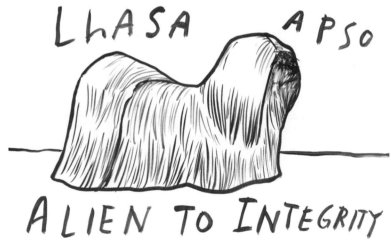

ALIEN TO INTEGRITY

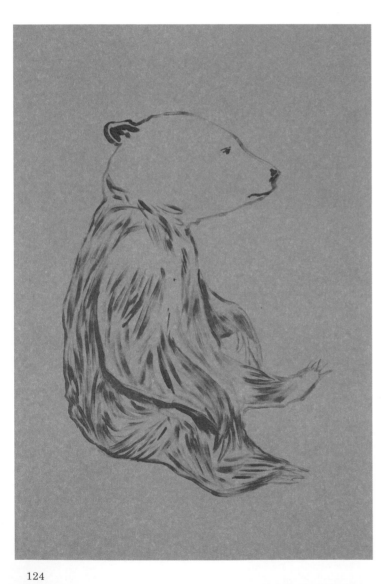

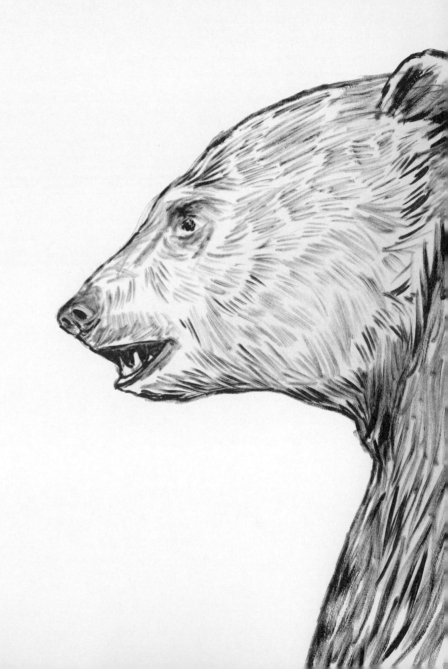

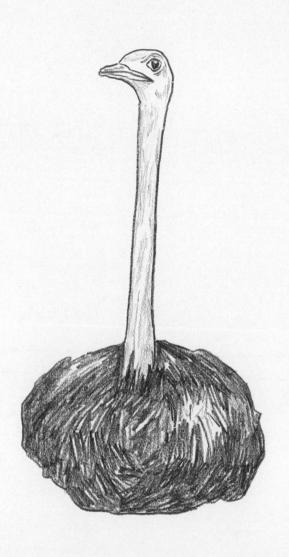

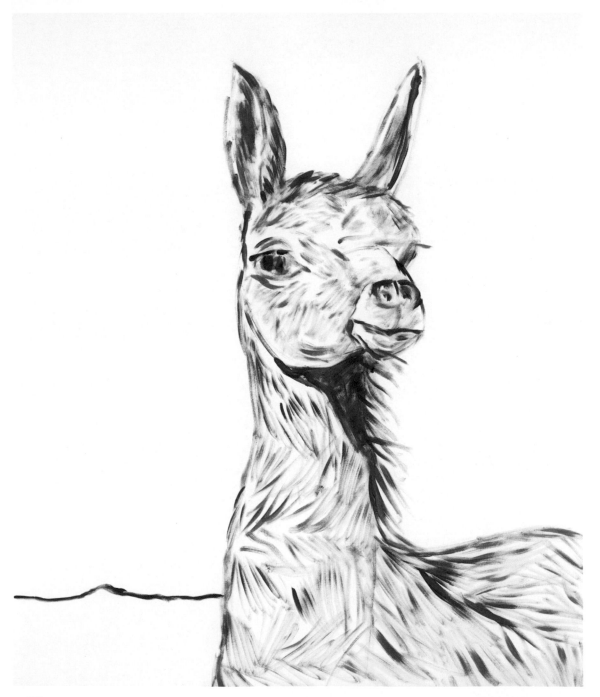

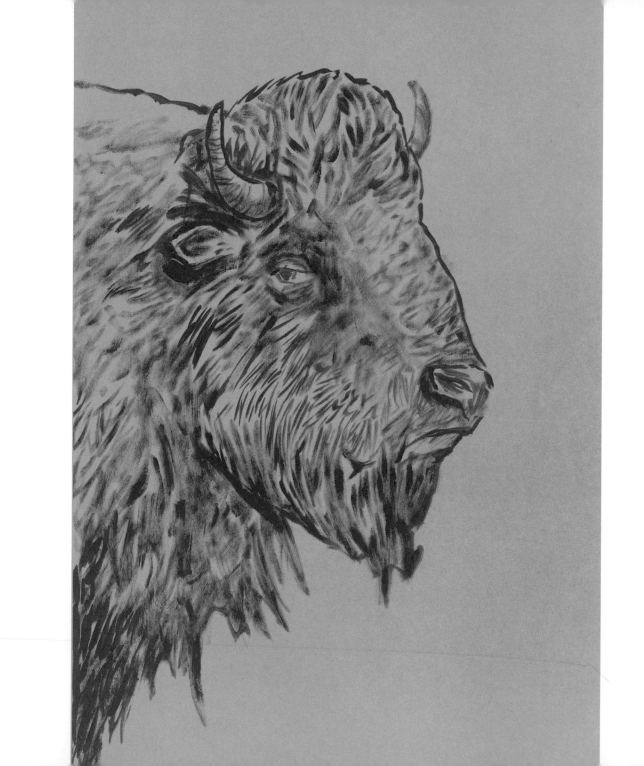

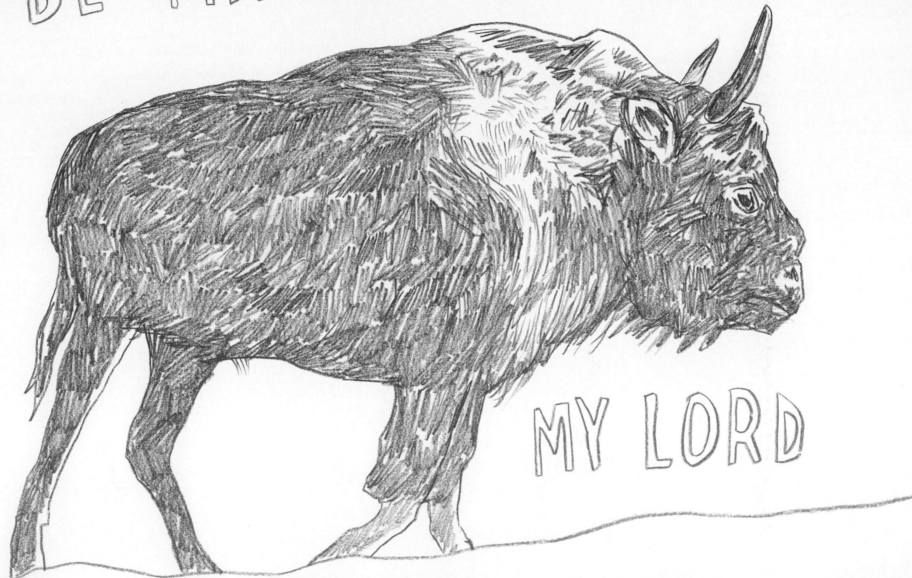

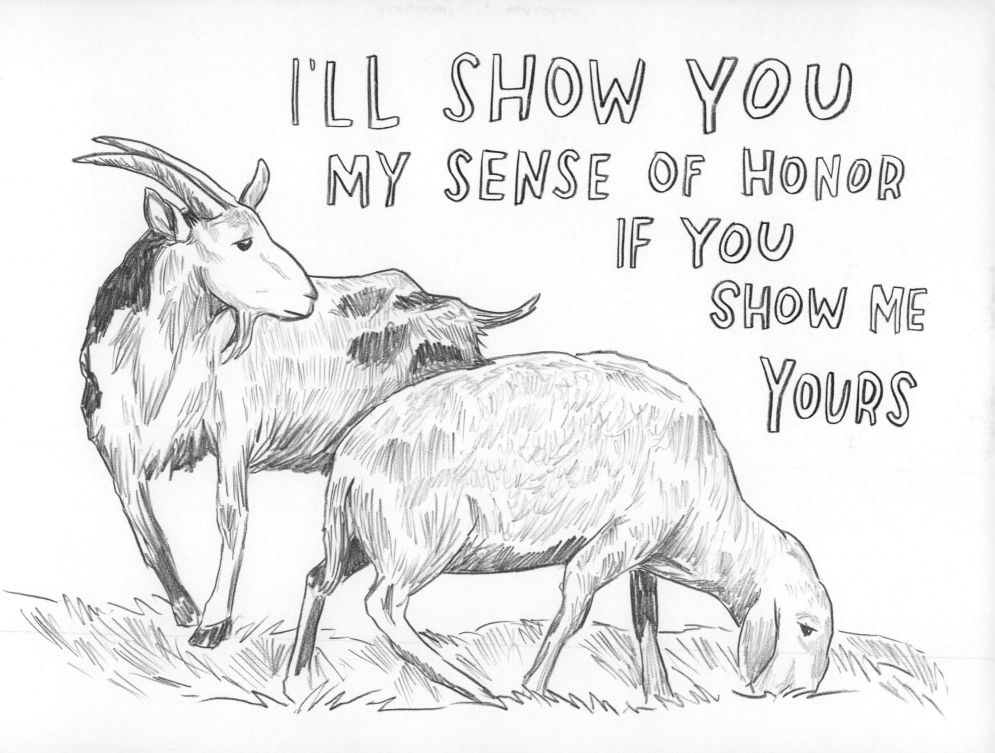

VICTORY

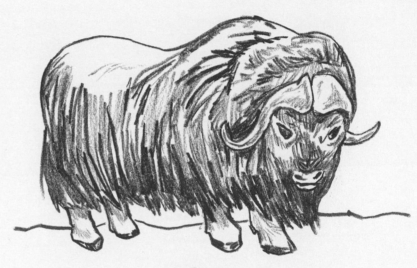

IS
WINNING
PLUS
DEATH

I LOVE YOU TOO MUCH TO LOVE YOU

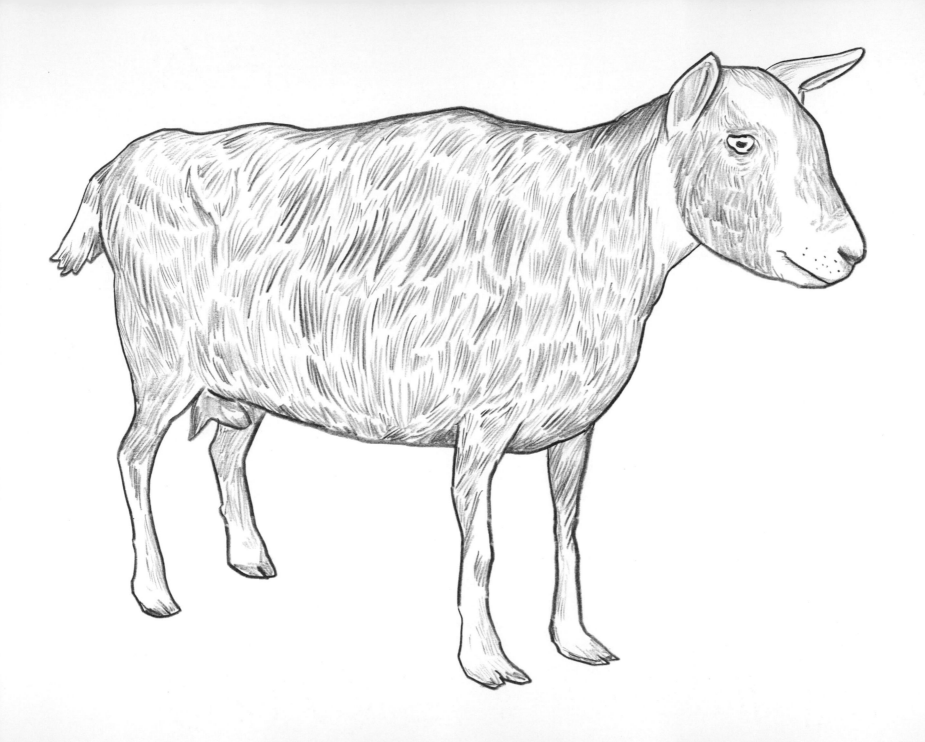

THE WICKED SHALL BE A RANSOM FOR THE RIGHTEOUS

SEE, I HAVE
SET THEE OVER
AND
OVER
THE
KINGDOMS,

THIS DAY
THE NATIONS

TO ROOT OUT,
AND TO PULL
DOWN, AND TO
DESTROY, AND TO
THROW DOWN,
TO BUILD, & TO PLANT.

THAT I MAY SEE
THE GOOD OF
THY CHOSEN.
THAT I MAY
REJOICE
IN THE GLADNESS
OF THY NATION.
THAT I MAY
GLORY
WITH THINE
INHERITANCE.

Trained in classical drawing technique at the Art Institute of Chicago, the American Academy of Art, and the University of Illinois, Dave Eggers identified as a visual artist before his success as a novelist propelled him into the literary world. Eggers was also a cartoonist for many publications and newspapers creating laughs with social critique. His multivalent talents open up a field of making where boundaries no longer exist: The writer is unable to abandon text just as the painter is unable to abandon the image. We are confronted with what happens when you are the rare hybrid writer-painter like Dave Eggers, a new form is created that is somewhere between handwriting and drawing, between cartoon and fine art.

In line with his fellow friend and acclaimed British artist David Shrigley's drawing practice, Eggers's works highlight an appreciation of the absurd and the necessity for humor. From a collaboration between artists Raymond Pettibon and Marcel Dzama at David Zwirner Gallery in 2016, we can begin to piece together a contemporary art family genealogy of artists who include Eggers, sharing in the pained and political, mundane and heroic, biblical and secular, doodle and fine art–making

trajectory. We also can't help but reference modernist art history and Magritte's famous 1948 painting of a pipe with the text, "This is not a pipe" (appropriately entitled *The Treachery of Images*) that plays with the idea that the word is not the thing, just like the map is not the territory. This is not what we think it is. Like Magritte, Eggers's drawings are meta-messages operating in a world where words and images are unstable and unpredictable.

This artwork is confounding, hilarious, and sad. Using the cartoon, satire, and surrealist delivery systems of image and text, most of Eggers's drawings—china marker and acrylic on paper or wood panels—are of animals paired with rejoinders from everyday life or quotes from the Bible, which Eggers regards as poetry. Like *Los Caprichos* (*The Whims*), Goya's light-hearted fantasy etchings drawn at the turn of the eighteenth century (1799-1803), which were informal in style but heavy with social critique, Eggers's drawings imbue animals with what they don't have and what distinguishes them from humans—that is, language.

In Goya's *Caprichos* we discover a donkey seated at the table with captions like "Neither

More or Less" or "And so was his grandfather" or "Might not the pupil know more." And Eggers, as if he were eavesdropping in a San Francisco Mission neighborhood cafe, will pair an image such as of a fruit bat with a subtitle—"Jennifer would like to use your location"—underlining the oddity of both the words and the mammal. Pairing a flamingo with the text "Oh My God, I Thought There Would be More of Everything," a Tibetan spaniel with "Not a factor in 2016," or a soft-coated griffon with "Never Truly Cared About Your Insincerity," we enter into a universe which is at once absurd, comical, and tender. Serious issues such as death, love, and social insecurity are tackled head on with wit and angst. Their strength lies in deceptive simplicity and the power of engaging the viewer with laughter.

But really, Dave Eggers is first and foremost a storyteller. Eggers likes to tell the story of the bison accompanied by the text "Exalted by Ennui." The artist has watched the bison in Golden Gate Park over the years and has never seen them move. These majestic creatures rendered almost extinct by colonizing hunters elude the viewers and remain as far away from their sightline as possible. Even the official park literature reads, "Don't expect a grand show of movement and daring feats when visiting the bison. They tend to keep to themselves and really don't engage in any exciting activities. If you are lucky, one of the bison may slowly travel from the field to the corral."

Eggers imagines the "What if ...?" What if these creatures of American West legend are, in fact, not sedentary and lethargic but rather, what if they were "Exalted by Ennui"? What if these Eggersian animals actually suffered from the nineteenth-century human condition described by the poet Baudelaire as "ennui"? What if, one day, these beasts break free of their real and figurative shackles and escape? What if the bison has found an exalted state—a eureka moment—in his condition of capture and paralysis?

Dave Eggers's work is deeply personal. Each drawing seems oddly idiosyncratic, almost painfully revealing of a deeply hidden secret. Taken individually, each is like a snapshot of a larger narrative, and a book of his drawings is like a fragmented text providing us with an antidote to everyday life, leaving us to make our own interpretations from the playful images. Eggers's drawings are often humble and mundane and one could think of his work as the art version of a political cartoonist, a Goya for the new age, a raw distiller of everything that lies under the surface. The collector of "What ifs ...?" Eggers teases us in a game of "Must we mean what we say?"

Natasha Boas, PhD, is an international contemporary art curator, writer, and professor. Over her twenty-five years in the art world, she has organized exhibitions with a wide range of artists such as Sophie Calle, Chris Johanson, Barry McGee, Clare Rojas, James Turrell, Fred Tomaselli, and Dave Eggers. Boas has worked for the Centre Pompidou, Grey Art Gallery, NYU, the Berkeley Art Museum Pacific Film Archives, and other distinguished arts institutions. She resides between San Francisco and Paris.

ACKNOWLEDGMENTS

Dave Eggers would like to thank: Everyone at Abrams who thought this book a reasonable idea: Paul Colarusso, David Cashion, and John Gall. Noah Lang, Kris Lang, and Richard Lang at Electric Works, for risking their reputations on this work. Mr. Hjortness, my high school art teacher. Natasha Boas. At the Jules Maeght Gallery: Jules Maeght, Amelie Marliac, and Luc Sokolsky. All at the Nevada Museum of Art: JoAnne Northrup, David B. Walker, and David Tilley. Everyone at the Museum of Contemporary Art in Detroit: Elysia Borowy-Reeder, Amy Corle, Augusta Morrison, Zeb Smith, and Ayaka Hibino. Amanda Uhle. Meagan Day. Em-J Staples. Jesse Nathan. Marcel Dzama. David Shrigley. B, V, and A.

Noah Lang would like to thank: Kris, Clementine, and Aloysius Lang for making this sparkling and thorny endeavor of life worthwhile. And my sister, Amelia Lang, for getting the whole ball rolling on this book. It wouldn't be, if not for you.

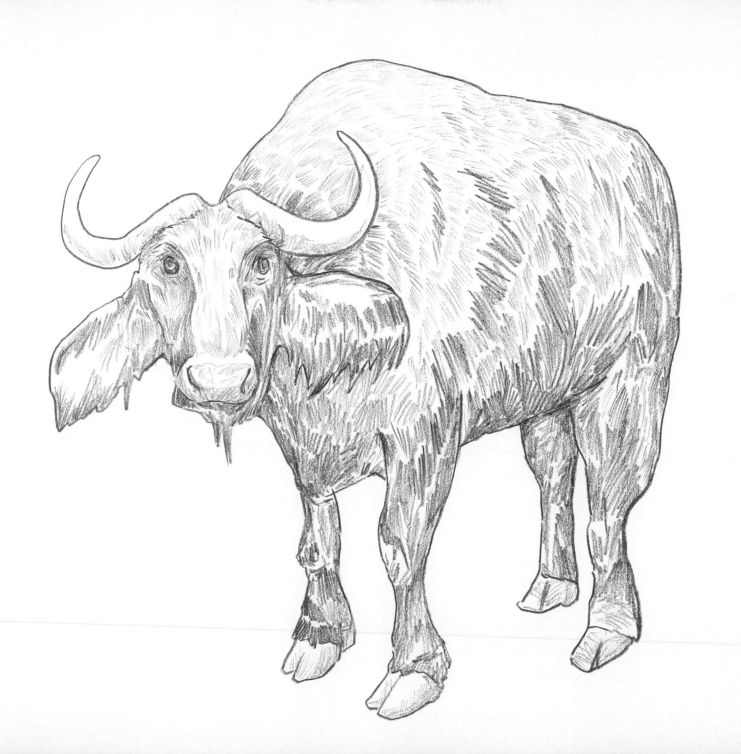

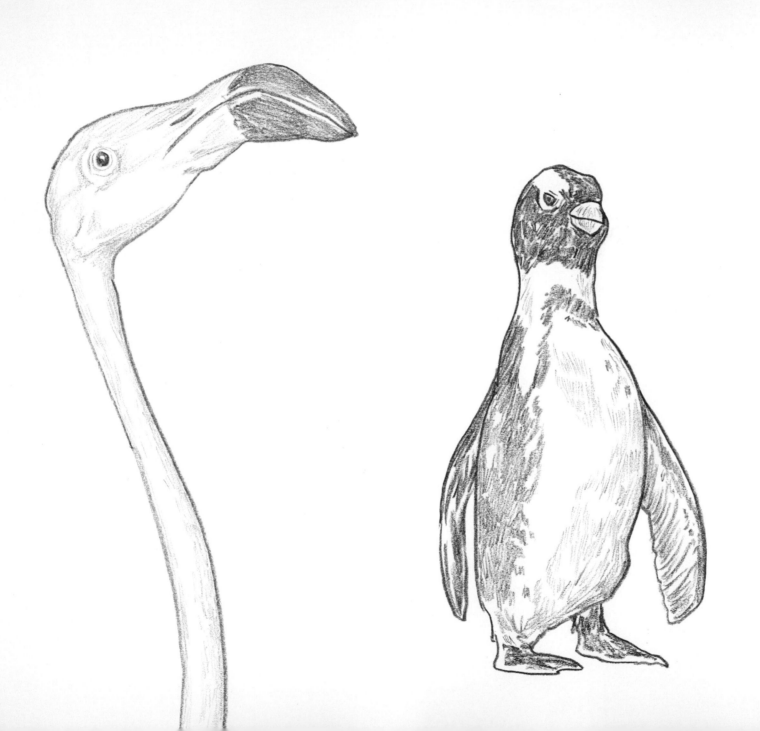

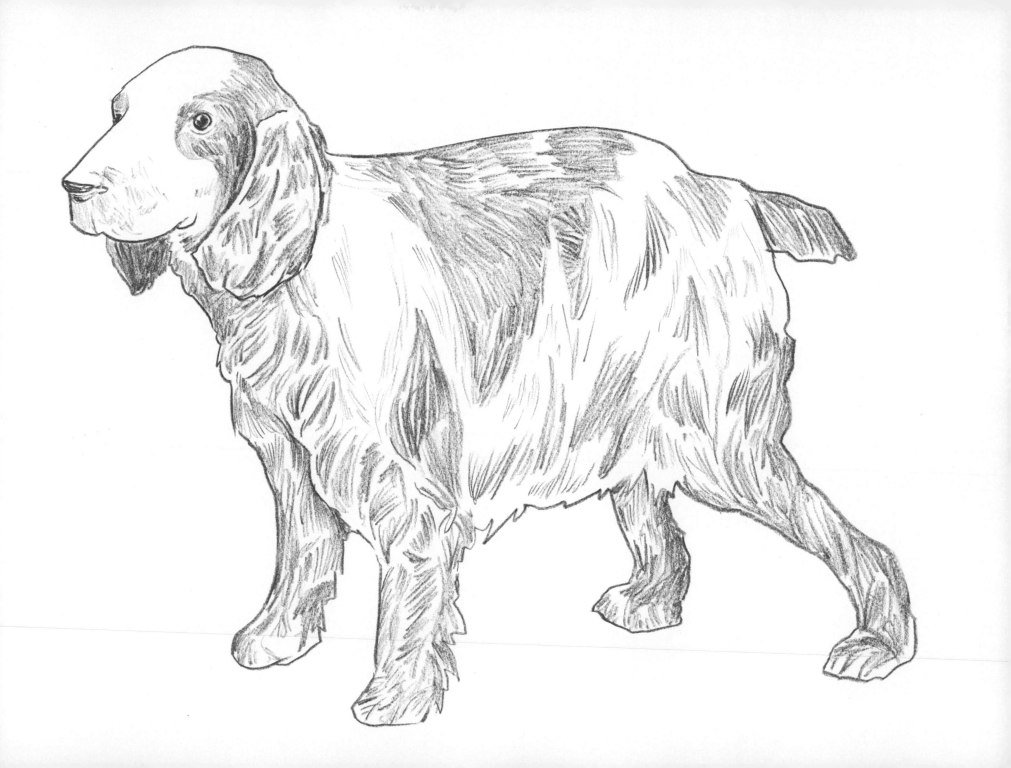

Editor: David Cashion
Designer: John Gall
Production Manager: Denise LaCongo

Library of Congress Control Number: 2017930296

ISBN: 978-1-4197-2463-3

Printed and bound in China
10 9 8 7 6 5 4 3 2 1

Abrams books are available at special discounts when
purchased in quantity for premiums and promotions
as well as fundraising or educational use. Special
editions can also be created to specification. For
details, contact specialsales@abramsbooks.com or the
address below.

ABRAMS
The Art of Books

115 West 18th Street
New York, NY 10011
abramsbooks.com

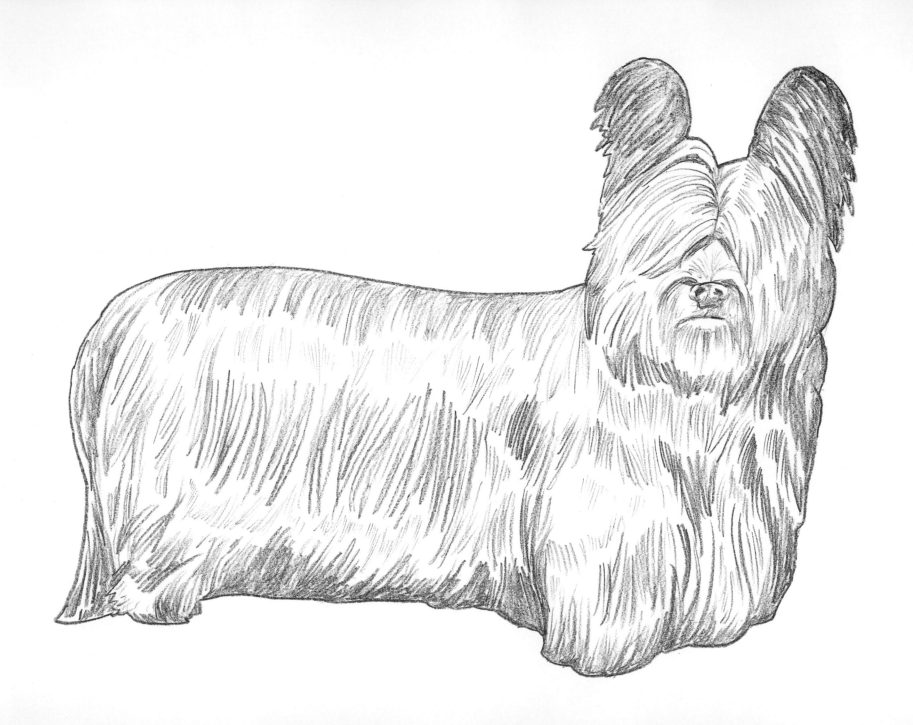